VINCENT'S ARLES

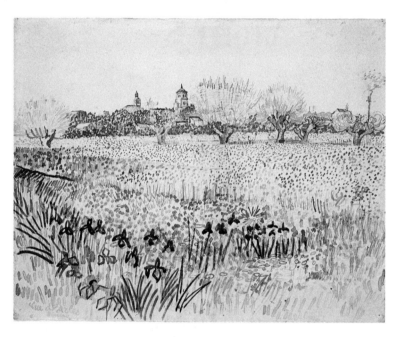

A meadow full of very yellow buttercups, a ditch with iris plants with green leaves, with purple flowers, the town in the background, some grey willow trees—a strip of blue sky.

Vincent van Gogh, May 12, 1888

VINCENT'S ARLES

AS IT IS
&
AS IT WAS

LINDA SEIDEL

THE UNIVERSITY OF CHICAGO PRESS · CHICAGO AND LONDON

The University of Chicago Press, Chicago 60637
The University of Chicago Press, Ltd., London
© 2023 by The University of Chicago
All rights reserved. No part of this book may be used or reproduced in any manner whatsoever without written permission, except in the case of brief quotations in critical articles and reviews. For more information, contact the University of Chicago Press, 1427 E. 60th St., Chicago, IL 60637.
Published 2023
Printed in the United States of America

32 31 30 29 28 27 26 25 24 23 1 2 3 4 5

ISBN-13: 978-0-226-82219-8 (cloth)
ISBN-13: 978-0-226-82298-3 (e-book)
DOI: https://doi.org/10.7208/chicago/9780226822983.001.0001

Frontispiece. Vincent van Gogh, *View of Arles*, 1888. Reed pen and ink and wash over graphite on paper, 43.2 × 54.6 cm (17 × 21½ in.). Gift of Mrs. Murray S. Danforth, Museum of Art, Rhode Island School of Design. Courtesy of the RISD Museum, Providence, RI.

Library of Congress Cataloging-in-Publication Data

Names: Seidel, Linda, author.
Title: Vincent's Arles : as it is and as it was / Linda Seidel.
Description: Chicago : The University of Chicago Press, 2023. | Includes index.
Identifiers: LCCN 2022016224 | ISBN 9780226822198 (cloth) | ISBN 9780226822983 (ebook)
Subjects: LCSH: Gogh, Vincent van, 1853–1890—Homes and haunts—France—Arles. | Arles (France)—Description and travel.
Classification: LCC DC801.A71 S45 2023 | DDC 914.49/1804—dc23/eng/20220429
LC record available at https://lccn.loc.gov/2022016224

♾ This paper meets the requirements of ANSI/NISO Z39.48-1992 (Permanence of Paper).

FOR

*Abby, Lilly, Ella, Izzy, Thomas, Helen, and Lp,
whatever paths they follow in their journeys*

Yesterday, at sunset, I was on a stony heath where very small, twisted oaks grow, in the background a ruin on the hill ... You wouldn't have been at all surprised to see knights and ladies suddenly appear, returning from hunting with hawks, or to hear the voice of an old Provençal troubadour.

VINCENT VAN GOGH, JULY 5, 1888

CONTENTS

Preface {xi}
Maps {xiv}

Poets of the Place {1}
The Art of Colors and the Art of Words {12}
The Road to Remembrance {37}
"A Little Rome of Gaul" {51}
The Portal and Its Past {72}
Seeing Stories {89}
Crossroads of the Mediterranean {103}
Pilgrimage Facts and Fictions {114}
Journey's End {127}
Afterwords {133}

Index {145}

PREFACE

Arles has changed in conspicuous ways during the past few decades, embracing its once neglected Roman heritage, creating new venues for the display of art and antiquities, and memorializing the places where its most famous resident, Vincent van Gogh, lived and worked for fifteen months toward the end of his short life. I have visited it many times during these years, primarily to study the portal of its medieval cathedral, Saint-Trophime. In the twelfth century, when the church and its richly carved entry were being constructed, Arles was a place pilgrims passed through seeking blessings at the burial sites of notable saints. Walks I took through Arles in pursuit of the paths they had taken made me see myself in their likeness, as a petitioner searching for satisfaction through contact with places hallowed by others.

Vincent, I realized, belonged to that cohort too. He had gone to Arles looking to improve both his health and his painting. Now others were coming to the city to see the places where he

had wandered and worked; their activity was turning those sites into secular shrines. Descriptions in his letters of things he encountered as he moved through the landscape and what they brought to his mind led me to think in unexpected ways about a town and a church I thought I knew well. What I discovered as I saw Arles through Vincent's eyes reinforced my sense that what we find in our journeys—scholarly, devotional, and personal—is shaped by things that come into our purview serendipitously as much as it is by expectations of what we set out to find. These intermingle as we proceed, affecting the realizations we arrive at when our travels come to an end.

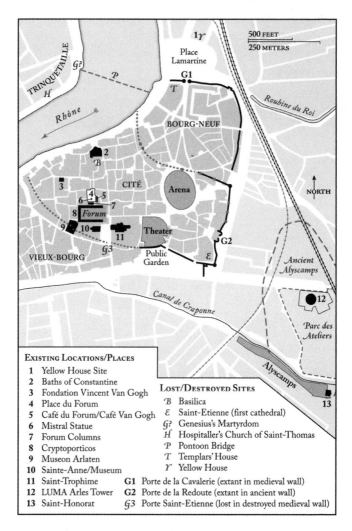

Map 1. Arles, France. Map created by Kate Blackmer.

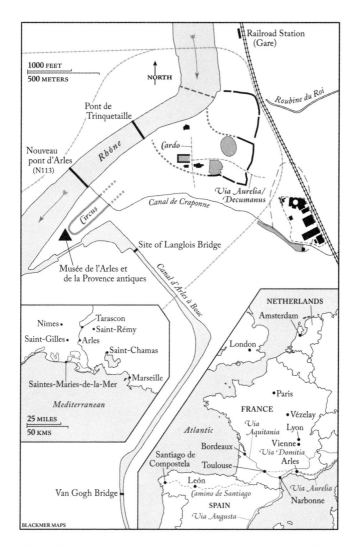

Map 2. Roman sites and other points of mention around Arles. Map created by Kate Blackmer.

POETS OF THE PLACE

Toward the end of October 1888, Vincent van Gogh went to the Alyscamps to paint. He was accompanied by Paul Gauguin, who had just arrived for what turned out to be a shorter stay than either of them foresaw. To get to the burial ground, they had to walk from where they were living, in the yellow house at the northern edge of the city, through a small park outside one of the gates in Arles's extant wall and along meandering streets, passing either the massive Roman arena in the higher part of town or the twelfth-century church of Saint-Trophime on the edge of the main square. The ancient cemetery had become, by then, an abruptly abbreviated necropolis. The works they produced there over the course of a couple of days, of tombs amid colorful foliage, record the different perceptions each had of what was still a storied place (plate 1).

The route reversed the one that pilgrims in the twelfth century would have taken after offering prayers at the burial sites of

{2} POETS OF THE PLACE

Gaul's earliest holy men. From the cemetery, those pious travelers passed through one of the gates in the wall on the city's south side, stopping at the newly built cathedral to venerate the relics of its patron saint, Trophimus. A short walk north and west took them to the bridge across the Rhône, near the spot on the other side of the river where Genesius, an early martyr, had been beheaded. As I traced their passage through Arles, imagining places that might have caught their attention, I wondered what they would have thought of them as they passed by. Had they found what they set out to look for as they journeyed, as Vincent had done while en route to Provence (figure 1)?

"I still have in my memory the feeling the journey from Paris to Arles gave me this past winter. How I watched out to see 'if it was like Japan yet!'" he wrote Gauguin shortly before the latter's visit.

Vincent's journey began on Sunday, February 19, 1888. The train he boarded passed through Lyon and traveled alongside the Rhône, through Vienne, before arriving in Arles the following day in the middle of a snowfall. In letters written to his brother and sister soon thereafter, he explained that he had decided to leave Paris because winter in the French capital adversely affected both his health and his work. People were demanding varied and intense colors in paintings, rather than the gray palette he had been using, and he wanted to change his ways. As he traveled, thoughts of contemporary Japanese woodcuts he had been collecting shaped his expectation of what he would see in the Provençal countryside. Even before reaching Arles, he had found what he was searching for from the window of the train:

> rows of little round trees with olive-green or gray-green foliage . . . plots of red earth . . . with mountains in the background of the most

POETS OF THE PLACE {3}

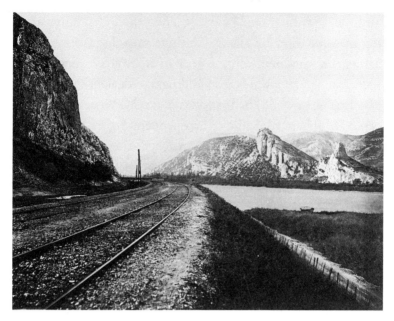

Figure 1. Édouard-Denis Baldus (1813–89), *Entrée du Robinet*, ca. 1861. Albumen silver print from glass negative, 33.3 × 43.2 cm (13⅛ × 17 in.). Gilman Collection, gift of the Howard Gilman Foundation, 2005. Image: Courtesy of the Met's Open Access program. Metropolitan Museum of Art, New York City.

delicate lilac. And the landscape under the snow with the white peaks against a sky as bright as the snow.

This letter to his younger brother Theo was the first of approximately two hundred Vincent wrote to family members and friends during the more than two years he spent in Provence. For most of that time, he lived in Arles; following his stay there, he moved to an asylum at Saint-Rémy, twenty miles away. The letters to his brother often begin either with a request for money desperately needed for living expenses and art supplies, or with acknowledgment of its receipt: "Thanks for your kind letter

and the 50-franc note," he wrote Theo three days after arriving in Arles. They invariably continue with discussions of the art market, comments on the work of other artists, and recommendations for how Theo should handle dealers in Paris and The Hague. News of Theo's success in getting Vincent's work accepted by the fourth Salon of Independent Artists, held in Paris from March 22 to May 3, 1888, reached Arles in early March. Vincent responded with the suggestion that two landscapes he had done in Montmartre the previous year should be submitted. When the show opened, he thanked his brother for the initiative he had taken. "All in all, I'm really pleased that they've put them with the other Impressionists," he wrote, requesting that in future shows he be listed as "Vincent and not Vangogh, for the excellent reason that people here wouldn't be able to pronounce that name."

By then, he had found the subject he thought most likely to attract interest, "studies of nature in the south," telling Theo that the market in The Hague would be the best place to promote his work. Ten days later he sent his brother a lengthy request for supplies, saying, "For Christ's sake get the paint to me without delay. The season of orchards in blossom is so short, and you know these subjects are among the ones that cheer everyone up."

Vincent's letters are best known for their remarkable documentation of some of the most beloved images ever made, which famously (but incorrectly) failed to attract attention during their creator's lifetime. They also trace a story of ups and downs in the mental and physical health of their writer, aspects of his life that have been sensationalized at the expense of other things about which he wrote at greater length. When Vincent wasn't wielding a brush or reed pen, he read vigorously, in at least three languages, peppering his letters with recommendations for fa-

vorite books and references to texts he found meaningful. He composed still lifes around his favorite tomes and occasionally incorporated "portraits" of what he had been reading into his compositions. In homage to works he admired, he suggested to Theo that the title of another one of the paintings included in the upcoming Independents' show, a colorful cascade of books he had done before leaving Paris for Arles, should be "Parisian novels." Its current title, *Piles of French Novels and Roses in a Glass*, subtly shifts understanding of the subject from celebration of Vincent's favorite reading to enumeration of his painting's objects.

Sometimes thoughts Vincent gleaned from his reading collided with what he was painting or looking at, causing him to experience things he saw as imbued with unexpected associations. Trees and flowering bushes, seen during his walks through the verdant Place Lamartine and the public garden, evoked Renaissance poets whose works he knew. This led him to imagine Petrarch and Boccaccio, who had spent time in the region centuries before, seeing things he was also seeing. Sunflowers, rocky outcroppings, and cypress trees, familiar features of the landscape, appeared to him as archetypal forms, and he likened the lines and proportions of the trees to those of an Egyptian obelisk, even though that is not how he painted them. What he could not have envisaged was that he would become an equally if not greater iconic presence in the region less than a century after his death.

Travelers arriving in Arles by rail, or disembarking from a river barge, encounter a place that has not changed much since Vincent descended from the train at the same location, at the northern end of the city, close to the city's curved embankment and a few steps from the park outside one of Arles's massive

gates. Their desire to see sites Vincent memorably captured—the bend in the Rhône, the house where he lived, the Café du Forum—is instantly satisfied. At these locations, the signage marking the places where Vincent stood while he was painting juxtaposes photographs of his canvas or cardboard panel with passages from the letters in which he described what he was trying to achieve. The strategically situated markers merge the places with Vincent's images of them, obscuring modifications that have occurred over the course of the century and making the sites seem more luminous and fraught than they are. Onlookers, inspired by the energy with which the painter transcribed what he saw, confound the renderings with what they represent. In the aftermath of a visit, it is difficult to differentiate between recollections of what has been experienced and what was foreknown because it had been glimpsed in a book or seen in a museum, whether on the wall of one of its galleries or on a tea tray in its gift shop.

The places Vincent painted have become proxies for his presence. A drawbridge he studied and painted on several occasions exemplifies the complexity and ironies of this situation. Several renderings he made of the bridge and the daily activity occurring along the water's edge emphasize the intense relationship he developed with his subjects, often painting them repeatedly in order to understand them better. At the same time, the hapless history that attends the original structure provides it with a legendary afterlife similar to those that embellished stories of medieval saints (figure 2).

The wooden bridge, which rested on stone supports, formed one of several crossings over a narrow canal built in the early nineteenth century to expedite transport between Arles and Marseille. It first captured Vincent's attention in mid-March 1888, when he mentioned it in a letter as the subject of a painting he

Figure 2. Vincent van Gogh, *Drawbridge with Walking Couple* (Langlois Bridge at Arles), letter sketch, March 18, 1888. Thaw collection, the Morgan Library & Museum, New York.

had just made "with a little carriage going across it, outlined against a blue sky." The "strange silhouette" of the bridge resembled structures dotting the Netherlandish landscape, and, within the next month, he made three other paintings of it under different conditions, with and without figures. Bombing during World War II destroyed the bridge and all but one of the many others crossing the canal. After the war, elements taken from the debris were reutilized for essential local building projects; widening of the waterway and construction of collateral roads altered the bridge's original setting. When a decision was made to reconstruct salvaged remnants of the lone surviving bridge in tribute to Vincent, a new site had to be identified on which the elements could be positioned.

Vincent referred to the original structure most often as Langlois Bridge. The one that seamlessly substitutes for it is known as Van Gogh Bridge. It is built out of an assortment of elements, some of which are old; few, if any, belonged to the original structure. The marshland on which it is installed was chosen because of its resemblance to the site on which the bridge Vincent painted had stood, enhancing the perception that the reconstructed structure is the one depicted in his painting even though that one was located a distance away. Visitors may not be aware of divergences between what they see and what he saw, since his rendering of it is likely fixed in their mind, predisposing them to match that memory with what they find. For them, this staging of one of Vincent's best-known subjects satisfies the need to believe that their feet are positioned (near) where he once stood as they see what (they imagine) he was scrutinizing as he worked.

Wartime bombing destroyed another one of the sites Vincent painted, the two-storied yellow house he depicted in September

POETS OF THE PLACE {9}

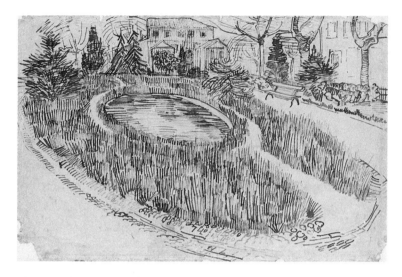

Figure 3. Vincent van Gogh, *The Park and Pond in Front of the Yellow House*, 1888. Pencil, pen, and reed pen and ink on paper, 32 × 50.1 cm (12$^{19}/_{32}$ × 19$^{11}/_{16}$ in.). Van Gogh Museum, Amsterdam (Vincent van Gogh Foundation).

1888, and which he hoped to turn into a studio for himself and Gauguin (figure 3). The building, located at the edge of the Place Lamartine, a short distance from the railway station, has not been rebuilt. Yet visitors search for the street corner on which it stood because of the role it played in the painters' story; it was the setting for their brief effort at collaboration and the site of Vincent's self-mutilation.

In early October 1888, Vincent sent Gauguin a description of a decoration he was planning for the room the artist would have when he came to Arles later that month, referring to it as the "garden of a poet." He noted that

> the unremarkable public garden contains plants and bushes that make one dream of landscapes in which one may readily picture

to oneself Botticelli, Giotto, Petrarch, Dante and Boccaccio. In the decoration I've tried to tease out the essence of what constitutes the changeless character of the region. And I'd have wished to paint this garden in such a way that one would think both of the old poet of this place (or rather, of Avignon), Petrarch, and of its new poet—Paul Gauguin.

He expressed similar notions regarding the presence of figures from the past in a letter written to Theo the previous month, marveling at seeing the same cypresses and oleanders that Petrarch had seen and saying that he had tried to "put something of that into one of the gardens" he was painting. At times, such thoughts interfered with what he was doing, as he noted in a letter to his artist friend John Peter Russell:

> And when I sit down to write I am so abstracted by recollections of what I have seen that I leave the letter. For instance, at the present occasion I was writing to you and going to say something about Arles as it is—and as it was in the old days of Boccaccio. Well, instead of continuing the letter I began to draw on the very paper the head of a dirty little girl I saw this afternoon while I was painting a view of the river with a greenish-yellow sky.

Two months after Gauguin's arrival in Arles, Vincent cut off part of an ear in one of the rooms of the yellow house following a feud that had broken out between them. Gauguin left Arles immediately thereafter; for Vincent, the event marked an intensification of the turmoil and illness that defined his life. Later that year, during his convalescence at the asylum in nearby Saint-Rémy, he replicated the painting he had made of his bedroom in the yellow house, telling Theo that eventually it would need to be

lined because it had been painted so quickly and dried in such a way that the thinner evaporated immediately and the paint didn't adhere firmly to the canvas. He also made another, smaller rendering of the chamber. Self-copying, as repetition and reduction, was a form of contemplation in which Vincent came to understand whatever he was looking at.

And so to find this truer and more fundamental character, this is the third time I'm painting the same spot....

This corner of a garden is a good example of what I was telling you, that to find the real character of things here, you have to look at them and paint them for a very long time. (plate 2)

THE ART OF COLORS AND THE ART OF WORDS

Vincent regularly culled images and descriptions from his reading, storing them in his mind, where they were ready for recall and revision. In one of his renderings of the fields outside Arles, the arcades of the arena and a few church towers appear in a vignette at the top of the paper; they are cut off from the harvest scene occupying most of the sheet's surface by a passing train (figure 4). A similar distancing of city from countryside occurs in a fifteenth-century manuscript with which Vincent was likely familiar. The calendar page for the month of June in one of the Duc de Berry's luxurious prayer books shows several recognizable Parisian buildings dominating the city's surroundings fields (figure 5). In 1884, the illumination was reproduced in a French journal Vincent had discovered a decade before, while working in London for the international art dealer Goupil. At that time, he had encouraged his brother to "read about art as much as possible, especially the Gazette-des-Beaux-Arts"; Vincent con-

tinued to reference things he saw in the journal from time to time thereafter.

A direct connection between the renderings is not at issue here, however tempting it may be to imagine Vincent associating the depiction of medieval peasants with what he had seen in the Netherlands and then interpolating that into a rendering of Arles's agricultural surroundings. What resonates are distinctions in the treatment of the pages. The patron/reader of the medieval manuscript associated himself with what he saw at the top of the parchment leaf on which the image is painted. From this elevated perch, he established his superior relationship to the women and men cutting and raking grain, looking down on them in accordance with his era's hierarchical understanding of how to read vertical surfaces. The nineteenth-century draftsman worked within a tradition that perceived the rectangular sheet of paper as a window through which an onlooker peered. The proximate, lower area from which the wheat has been gathered provided his point of entry. From there, the city looms as a distant, inaccessible entity, alienated from the landscape.

And that is how Vincent saw Arles. The affinity he felt for its surroundings did not extend to the still-remarkable architectural monuments comprising its core. A painting he made of the crowd attending a bullfight in Arles's Roman arena lacks any hint of the ancient structure's defining forms—its arched openings and vaulted passages. Instead, it focuses on the array of spectators filling its semicircular stone benches (figure 6). At the left, three women in local dress, dark hair piled high and faces framed by the traditional shawl-like collars of their garments, evoke those in Utamaro's woodblock print of *Three Beauties of the Present Day*. Vincent had gone to the south of France expecting it would look like a place he had come to know

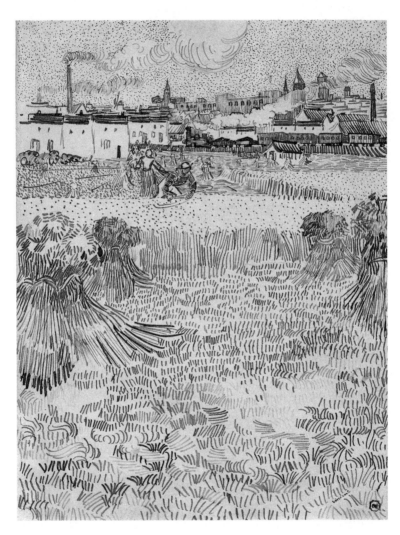

Figure 4. Vincent van Gogh, *Arles: View from the Wheatfields*, 1888. Reed and quill pens and brown ink, 31.2 × 24.1 cm (12⁵⁄₁₆ × 9½ in.). Courtesy of the Getty's Open Content Program. J. Paul Getty Museum, Los Angeles.

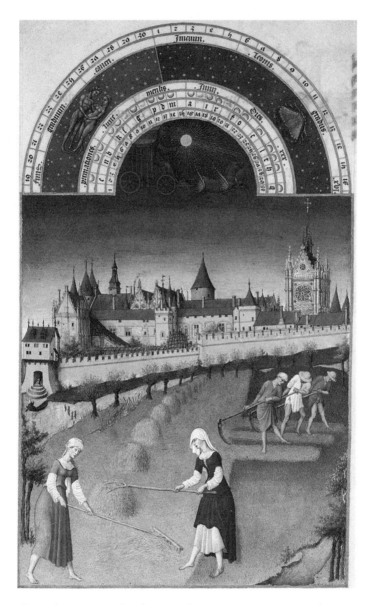

Figure 5. Herman, Paul, and Jean Limbourg (1380s–1416), *Très Riches Heures du Duc de Berry*, Folio 6, verso (June), 1412/16–1485/86. Paint on parchment, 22.5 × 13.6 cm (8^{27}⁄$_{32}$ × 5^{23}⁄$_{64}$ in.). Musée Condé, Chantilly, Oise.

{16} THE ART OF COLORS AND THE ART OF WORDS

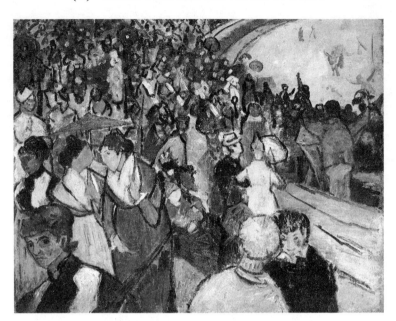

Figure 6. Vincent van Gogh, *Arena at Arles*, 1888. Oil on canvas, 73 × 92 cm (28¾ × 36¼ in.). State Hermitage Museum, Saint Petersburg.

in his imagination, and he made what he found there match the images he carried with him, those packed in the bags he carried and those stored in his mind. Seven months after his arrival he remarked that he no longer needed Japanese prints, because "I'm always saying to myself that I'm in Japan here."

In addition to sites he painted that were later destroyed by Allied firepower, at least one of his canvases of the countryside surrounding Arles was the victim of collateral damage. The painting, which belonged to a museum in Magdeburg, Germany, showed Vincent walking along the road to Tarascon in search of a subject to study. It disappeared either during the bombing of the city, or in a fire that ravished the nearby salt mine where it had been stored for protection with other notable works. The

painting may still exist. Full knowledge of the whereabouts of art that vanished in those years is lacking; some is known to have been privately appropriated and could still be hidden.

Vincent referred to the painting in a letter he wrote in mid-August, in which he alerted his brother to the arrival of a parcel of thirty-six studies being brought to Paris by a courier. Among them, he noted, was "a quick sketch I made of myself laden with boxes, sticks, a canvas, on the sunny Tarascon road." Two months before, he had described himself more colorfully in a lengthy letter to his sister as "always dusty, always more laden like a porcupine with sticks, easel, canvas, and other merchandise." In the lost painting, he appears as a jaunty figure facing left, walking away from one unseen place and toward another. The image survives on paving stones scattered throughout the city in the 1960s to guide pedestrians searching for the sites at which Vincent set down his easel. Over the course of the years, a civic effort to facilitate tourists' passage through Arles's streets placed additional images of him carrying the tools of his trade alongside hieroglyphs for ancient and medieval monuments (figure 7).

The painting is gone but has not been forgotten. The little figure has become a local icon, while its setting endures in two drawings. In one of them we see the two trees and the field bounded in the distance by cypress trees; the painter's presence lingers in the boldness of the drawing's lines (figure 8). Precisely rendered dots, strokes, and swirls record the pressure of Vincent's hand and the density of the ink clinging to his reed pen as he paused on the way to Tarascon to set down features of the terrain. Travelers through the countryside north of Arles, following the flat, tree-lined road Vincent rendered, imagine themselves caught in a time warp, expecting him to come along with his palette and paints.

Figure 7. Street tiles marking monumental routes. Photo by author.

Pilgrims long ago had similar reactions to places through which they passed. Those journeying to Saint James the Great's tomb, in northwestern Spain, associated sites in the Pyrenees with heroes whose movements and deeds they imagined themselves reenacting. Roland, the valiant soldier who died in the mountains near Roncesvalles in the eighth century, is invoked in the twelfth-century *Pilgrim's Guide* when reference is made to the pass through the Pyrenees where he expired. An elevated spot nearby, where Charlemagne purportedly erected a cross and offered a prayer to Saint James, is described in the text as cluttered with crosses planted by pilgrims in emulation of the emperor's act. For the twenty-first-century traveler, Vincent's link with the Provençal landscape has become providential in the way that the tie between Carolingian heroes and the Pyrenees was for medieval pilgrims.

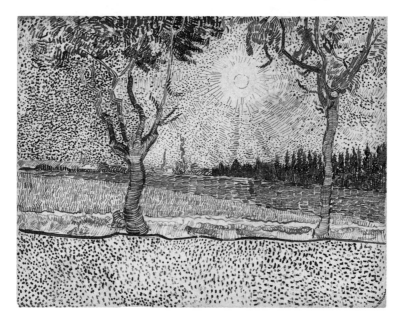

Figure 8. Vincent van Gogh, *The Road to Tarascon*, 1888. Reed pen and ink over graphite on paper, 24.3 × 31.9 cm (9½ × 12½ in.). Thannhauser Collection, gift of Justin K. Thannhauser, 1978. Solomon R. Guggenheim Museum, New York.

It was not unusual in distant centuries for pious travelers to take away pieces of trees or bits of the terrain near a revered site as mementos of their trip; sometimes these were thought to have healing properties. Pilgrims visiting the shrine of Saint Genesius on the riverbank near the bend in the Rhône believed that the branches they took from a mulberry tree growing near the early martyr's tomb had therapeutic capabilities. Vincent was attracted to the colorful foliage of a mulberry tree one superb autumn day in October 1889 while living at Saint-Rémy. The painting he made of it shows the tree as pilgrims would have encountered it in that season, laden with brilliant yellow foliage (plate 3). Year-round, travelers to the tomb of Saint James

picked up cockleshells on the seashore not far from his shrine, placing them on their cloaks, bags, or hats as tokens of their visit (figure 9). The shells commemorated the voyage the saint's remains made to the Iberian Peninsula as well as the trip those displaying the shells had undertaken to reach his relics. Each shell's uniqueness reflected the individual nature of the pilgrim's experience. Nowadays, travelers' photos replicate that activity. The images they carry away of cypress trees or a bridge testify to their intimate engagement with a place made famous through its connection to a renowned individual's accomplishments.

In some instances, objects carried by medieval pilgrims to aid in the viewing of holy remains acquired sacred status. According to ancient theories of vision, sight occurred either through extramission, an activity in which beams of light emitted by the eye were thought to touch things, or intromission, a process that imagined material from objects penetrating the eye and reaching the mind. The Muslim astronomer Alhazen integrated the theories in his important early eleventh-century *Book of Optics* without dislodging the notion of physical contact between seer and seen. Pilgrims, unaware of the subtleties of his argument, nonetheless enacted them. Using mirrors to catch the reflection of obscurely positioned objects, they believed that the polished surfaces retained an image or imprint of whatever had momentarily been made visible. When this involved holy remains, the metal or glass surfaces that had captured a glimpse of sacred residue were regarded as hallowed substances, similar in sanctity to clothes worn next to a saint's body or a staff that a venerable figure had once held in his hand.

Vincent used a mirror to make his self-portraits, referring to it on several occasions in his letters. In one of them, he told Theo that he had "purposely bought a good enough mirror to

Figure 9. Relief on a corner pier in the cloister of Santo Domingo de Silos (Burgos, Spain). Photo by Wikimedia Commons user GFreihalter (CC BY-SA 3.0), creativecommons.org/licenses/by-sa/3.0/legalcode.

work from myself, for want of a model, because if I can manage to paint the coloration of my own head, which is not without presenting some difficulty, I'll surely be able to paint the heads of the other fellows and women as well." In another letter, he asked his friend Joseph-Michel Ginoux, the proprietor of his lodgings (and husband of the woman he painted as *L'Arlésienne*), to forward to Paris things he had left behind in Arles: "There is, for example, the mirror, which I'd very much like to have. You could stick strips of paper onto it to prevent it breaking," he noted. Although we no longer believe that light rays are emitted either by objects or by eyes, anyone standing before Vincent's self-portraits and observing his penetrating glance imagines it fixing on whatever he contemplated as he thought about how to paint it (plate 4). At the same time, the distinctive touch with which he captured the texture and energy of the faces, flowers, and fields he was scrutinizing makes us imagine his brush contacting the things he saw. Whereas the shiny implements pilgrims wielded were transformed into sacred objects through the reflections they captured, the places and people Vincent painted have achieved comparable status because of the renderings he made of them. For those who come to Arles looking for traces of Vincent, the sites he painted are imprinted with palpable memories of his presence.

Arles has sorely lacked, until recently, any paintings by Vincent. The Fondation Vincent van Gogh Arles, formally established in 2010 by a family devoted to cultivating the city's reputation as a venue for the arts, is committed to rectifying that lapse by exhibiting a few of his works, on loan from museums, for a few months each year. The borrowed panels provide visitors with tangible evidence of Vincent's touch, material marks confirming the painter's presence along with the works' authen-

ticity. The Van Gogh Museum in Amsterdam is a partner in this venture. It was established by Vincent's nephew and namesake with the transfer of the family's extensive holdings; these consisted primarily of paintings and drawings Vincent had either sent to his brother or kept for himself. When Theo died, a few months after Vincent, his wife, Jo Bonger, became responsible for their management. She carefully cultivated interest in them, according to a diary she dutifully kept, while raising her son, Vincent's namesake. She also preserved Vincent's letters to her husband. Publication of them in 1914, in their original languages and translated into German, made them accessible to a public slowly awakening to his art.

The directness of the voice that emerges in the letters addresses readers with the same immediacy as the brushstrokes in the paintings. Among the topics Vincent regularly wrote about were things he had read, many of which remained on his mind long afterward. He first mentioned Guy de Maupassant's *Bel-Ami* a few months after the book was published in 1885. A year later, he referred to it as "a masterpiece," saying, in a letter to his sister, Willemien, that he hoped to get her a copy of it. A month or two after that, he placed it prominently in the foreground of one of his paintings, *Still Life with Plaster Statuette*. The following year, he compared himself (dismissively) to the principal character in the book, a libertine Parisian journalist whose liaisons facilitate his rise from poverty. Around the same time, he wrote Willemien that a passage in the novel was related to the painting he was working on. Its description of a brightly lit café, which the protagonist of *Bel-Ami* passes one night while strolling along a Parisian boulevard, is "something like the same subject that I've painted just now," he told her (figure 10).

Within two months of arriving in Arles, Vincent asked his

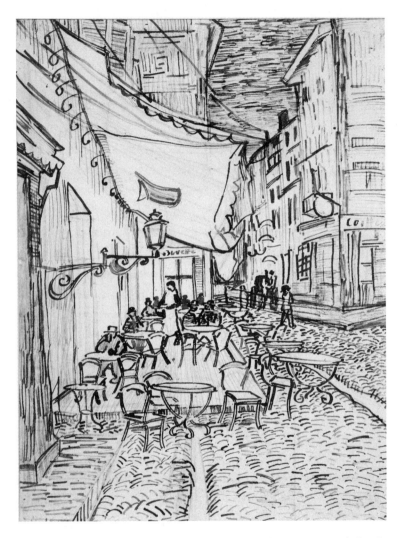

Figure 10. Vincent van Gogh, *Café Terrace on the Place du Forum*, 1888. Chalk, ink, and graphite on laid paper, 62.87 × 47.15 cm (24¾ × 18⁹⁄₁₆ in.). Wendy and Emery Reves Collection, Dallas Museum of Art.

artist friend Émile Bernard whether he didn't find it "as interesting and as difficult to say a thing as to paint a thing. There's the art of lines and colors, but there's the art of words that will last just the same," he said. Years earlier, he had sought to persuade his family that painting, which he was thinking of pursuing, was as elevated an endeavor as writing or preaching and as worthy of study. To justify what he was deciding to do with his life, he pointed out to Theo that there were similarities between the accomplishments of the greatest authors and artists.

> There are several things that are to be believed and to be loved; there's something of Rembrandt in Shakespeare and something of Correggio or Sarto in Michelet, and something of Delacroix in V. Hugo, and in Beecher Stowe there's something of Ary Scheffer.... And then there's something of Rembrandt in the Gospels or of the Gospels in Rembrandt, as you wish, it comes to more or less the same, provided that one understands it rightly, without trying to twist it in the wrong direction, and if one bears in mind the equivalents of the comparisons, which make no claim to diminish the merits of the original figures.

Vincent's study of the Bible during the time he trained for the ministry imbued him with a life-long interest in Christian imagery. "I've read the Bible better than many people nowadays, just because it gives me a certain peace that there have been such lofty ideas in the past," he wrote Willemien in the fall of 1887. His words render his remarks about the entry to Arles's Romanesque cathedral, which he sent to Theo a few weeks after arriving in the city, perplexing, since he says nothing in them about its religious subject matter. Instead, they suggest that other things were on his mind.

There's a Gothic porch here that I'm beginning to think is admirable, the porch of Saint-Trophime, but it's so cruel, so monstrous, like a Chinese nightmare, that even this beautiful monument in so grand a style seems to me to belong to another world, to which I'm as glad not to belong as to the glorious world of Nero the Roman.

Photographs of the entryway made in the 1850s show how blackened the structure had become over the course of seven centuries (figure 11). A late twentieth-century cleaning removed substantial encrustation and chemically secured the stones' stability, revealing their true colors to be a combination of white marble and local, golden limestone, along with various stones of lighter and darker gray (plate 5). The varied materials establish a hierarchy among the portal's parts, facilitating our negotiation of the diverse roles the stones play in the design of the structure. Had Vincent been able to see the glistening, multicolored stonework as clusters of distinct elements in the way we do now, his response to it might have been different. Even though the pastor's son had grown distant from the faith of his childhood, with its repudiation of Catholic dogma, he would have recognized the portal's Christian subjects more easily, possibly commenting, however randomly, on one or another of them.

Vincent's remarks on the carvings recall the way in which he wrote about the things he painted, not as accounts of subject matter but through reactions to shapes and colors or as reminiscences of objects and ideas that stimulated associations with his interior world of thoughts and fears. His choice of the word *Gothic* to identify an arrangement of sculptures Edith Wharton judged *Romanesque* and *exquisite*, when she visited Arles two years later, draws on specific associations the word had accrued during the nineteenth century that were engaging Vincent at

THE ART OF COLORS AND THE ART OF WORDS {27}

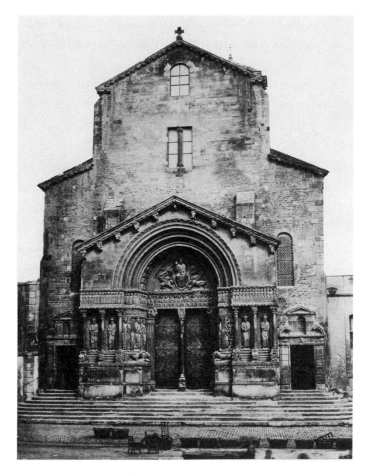

Figure 11. Édouard-Denis Baldus (1813–89), *Church of Saint-Trophime, Arles*, 1850s. Albumen silver print, 28.1 × 22 cm (11 1/16 × 8 11/16 in.). Courtesy of the Getty's Open Content Program. J. Paul Getty Museum, Los Angeles.

the moment he was writing. A decade and a half before, he had employed *Gothic* to characterize houses in London near the one in which he was then living. His use of the word in that context suggested the buildings were old and picturesque, probably constructed of wood and plaster in half-timber style. The word's

recurrence in a comment on a sculpted portal he associated with an infamous Roman ruler conjures up something different and darker.

The mauling lions at the feet of the figures in the entry, which confront the passerby at eye level, likely affected the way in which he took in the carvings. Toga-draped figures immediately above would have reminded him of an activity he had hated as an art student in Antwerp two years before, when he was obliged to copy ancient casts. He had complained then "how flat, how dead and how bloody boring the results of that system are," noting that a drawing he made of Germanicus would probably come in last in a competition because it deviated from the technique others in the class were dutifully employing. The weather could also have turned his mind inward: "Rain and wind these past few days," he wrote elsewhere in the letter, had kept him working at home on a study of two figures. His aim, "to give it colors like stained glass and a design of solid outlines," conjures up an association with one of the Middle Ages' signature forms.

Throughout the nineteenth century, the cathedral of Paris constituted the most celebrated Gothic structure in Europe; publication in 1831 of Victor Hugo's *Notre-Dame de Paris* brought attention to the crumbling building. Within a decade, the architect Eugène-Emmanuel Viollet-le-Duc began restoring it, adding an array of elements that it had not originally possessed but that he believed were appropriate for its decoration. The architect's notion of restoration argued for reestablishment of what was thought to be a building's authentic character, even if that involved misrepresentation of what it had originally looked like. Under his supervision, the repairs done to Notre-Dame transformed it from the symbol of shameful neglect that Hugo lamented into an icon of Christian architecture and a

metaphor for medieval life surpassing anything it represented at the time it was built.

Work on the building included installation of a group of grimacing bestial figures on the balcony running around the base of the towers. In 1853, Charles Méryon made one of these figures the frontispiece for a set of etched views of Paris (figure 12). The same year, the scowling creature appeared in a portrait Charles Nègre made of a fellow photographer, Henri Le Secq, standing on the tower's balcony. For those confronting the carvings in place or seeing the prints and photos of them, the figures generated associations with imagined medieval threats, as Michael Camille observed, some of which were viewed as surrogates for timely social and spiritual concerns.

The black birds in the background of Méryon's etching suggest that the artist had been inspired by the feathered visitor in Edgar Allan Poe's best-known work, *The Raven*. The poem became famous immediately after its publication in 1845 and was reprinted numerous times the following year. Méryon may have encountered it while visiting family in London in 1847, or a few years later, when Charles Baudelaire promoted Poe's writing in a lengthy study. The young French poet's presentation of the American author's work coincided with Méryon's production of the set of Parisian etchings. After the frontispiece was printed, the artist returned to the plate on which he had drawn the image, adding two lines of Gothic script between the oval frame enclosing the vignette and the edge of the metal surface. The opening words of the brief text, "insatiable vampire," associate the depicted creature with Poe's "ungainly fowl," the "ominous bird of yore" that haunts the narrator of the poem, besieging him with its presence while barely uttering a word. The inscribed words heightened the sense of foreboding the image already conveyed.

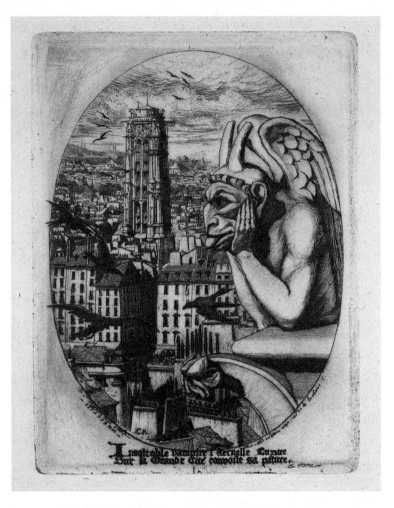

Figure 12. Charles Méryon, *The Vampire*, 1853. Etching in brown ink on green laid paper, fifth state of ten, 16.9 × 12.8 cm (6⅝ × 5 1/16 in.). Courtesy of the Met's Open Access Program. H. O. Havemeyer Collection, Bequest of Mrs. H. O. Havemeyer, 1929. Metropolitan Museum of Art, New York.

Vincent, who knew Poe's work, admired Méryon's etchings, marveling at their precision and power, saying that they made Viollet-le-Duc's drawings look like stone, and noting that they contained "something of the human soul, shaken by I know not what heartache." He wrote about the prints in a letter to Theo, likening them to what Dürer had expressed in his well-known engraving of *Melencolia* in which a winged female figure, surrounded by an accumulation of mysterious objects, sits brooding, her chin resting on her hand. In 1882, Vincent had considered acquiring three of Méryon's works but decided to purchase some wood engravings by another artist in a medium he found more interesting at the time. Yet the etcher of Gothic Paris, who suffered from mental illness and had died from starvation while institutionalized, in 1868, remained on the painter's mind. In various letters, Vincent identified the headaches and seizures plaguing him with Méryon's depression and delusions. In June 1888, he expressed concern that Gauguin's discouragement might lead him "to die like Méryon," and, in the fall of the year, Vincent wrote Theo about his own "horror a thousand thousand times of these melancholies à la Méryon!!!"

Méryon's etchings of Paris display an air of foreboding akin to what Vincent sensed in the portal, but the stranger work of Odilon Redon may have been closer to his mind when he chose the word *nightmare* to characterize his feelings about it. The uncanny subjects of Redon's drawings and lithographs had been evocatively described in J.-K. Huysmans's recently published book, *À Rebours*, as "hallucinatory ... fantasies of delirium and illness ... transpositions of Poe's writing"; the author likened them to things in a "scientific nightmare" (figure 13). Vincent had read the book and included Huysmans among the writers whose work he called "magnificent" in a letter to Willemien in

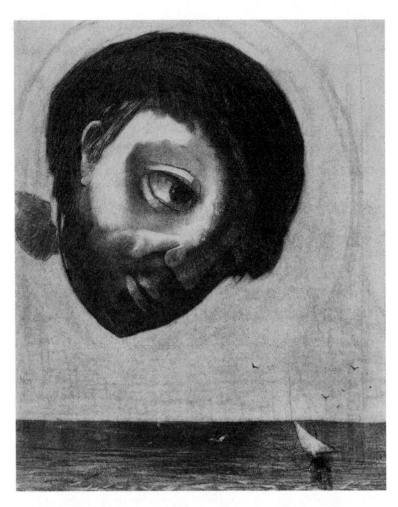

Figure 13. Odilon Redon (1840–1916), *Guardian Spirit of the Waters*, 1878. Various charcoals, with touches of black chalk, stumping, erasing, incising, and subtractive sponge work, heightened with traces of white chalk, on cream wove paper altered to a golden tone, 46.6 × 37.6 cm (18$^{11/32}$ × 14$^{51/64}$ in.). David Adler Collection, Art Institute of Chicago.

late October 1887. Immediately after arriving in the south a few months later, Vincent learned from Theo of the invitation to exhibit his work with the Society of Independent Artists, which Redon, along with Signac, Seurat, and three others had founded four years before. Might that have recalled for Vincent the strange work Huysmans had described? His use of the word *nightmare* to describe the portal three weeks later is the first of only four times the word appears in his existing letters according to their searchable database; the other instances of its use were directly associated with his headaches.

Vincent's choice of the word *Chinese* to modify *nightmare* likely came to him through his reading as well. China was a little-known place for Europeans in the nineteenth century, and Vincent repeatedly failed to differentiate it from Japan. In a letter written in 1883 to Anthon van Rappard, a fellow Dutch artist, Vincent incorrectly identified a wood engraving of a foundling hospital in Canton (now Guangzhou, China) as being in Japan. Two years later, after exposure to the Japanese woodcuts arriving in Dutch ports and their display at a world exhibition held in Antwerp, he again betrayed confusion about what or where China was, in a description of the city's waterfront. The docks, he wrote, looked like

> one huge *Japonaiserie*, fantastic, singular, strange ... [with] figures of the most diverse character.... There'll be Flemish sailors with exaggeratedly ruddy faces, with broad shoulders, powerful and robust, and Antwerp through and through, standing eating mussels and drinking beer, and making a great deal of noise and commotion about it. Contrast—there goes a tiny little figure in black, with her small hands pressed against her body, slipping soundlessly along the grey walls. In a frame of jet-black hair, a little oval face, brown?

Orange yellow? I don't know. She raises her eyelids momentarily and looks with a slanting glance out of a pair of jet-black eyes. It's a Chinese girl, mysterious, quiet as a mouse, small, like a bedbug by nature. What a contrast to the group of Flemish mussel-eaters.

Vincent didn't know her ethnicity; he saw her as a series of shapes and colors. What had brought her to his attention was her difference from the group of men with whom he could identify. After moving to Paris to live with Theo, in 1886, Vincent's interest in Japanese prints increased. He bought inexpensive copies of the works of seventeenth- and eighteenth-century masters, copying them in order to study their unusual modes of composition and exhibiting some of these works in 1887 in a café in Montmartre run by a girlfriend. Fascination with Japan took him to Arles the following year, where his fondness for Japanese imagery intensified while his awareness of China languished. In 1889, Vincent referred to the subject of a print by Moronobu, a copy of which he had in his room, as a *mandarine*, inventing a feminine form of the word for a Chinese official to describe the (Japanese) woman in the picture.

Vincent was not alone in his ignorance. Throughout the nineteenth century, many perceived China to be a remote and inaccessible place and knew little about it. That is how it is presented in Honoré de Balzac's best-known work, *Le Père Goriot*, published in 1835. Early in the story, the protagonist is asked by a friend what he would do if he could become rich by secretly willing to have a mandarin in China killed. The question, presented as one of Jean-Jacques Rousseau's ideas, is introduced in order to explore the relationship between morality and proximity and is intended to test the social-climbing Rastignac's empathy for a distant place and its people.

The detached way in which Balzac used China to make a point reverberates in Vincent's characterization of the portal. The painter may have remembered the example, having recommended the book to Theo in 1881, saying then that once "you've tasted Balzac you'll prefer it to a great many other things." But another writer's words were more likely on his mind. Immediately before describing the church entry, Vincent said how taken he was with Maupassant's preface to the short novel *Pierre et Jean*, in which the author comments extensively on contemporary writing, condemning the "bizarre, complicated Chinese vocabulary" that is used in much of it, and encouraging writers instead to "transform . . . unchanging, brutal and disagreeable truth . . . so as to please, move or touch the reader." The word *Chinese* had clearly caught Vincent's eye. As though to reinforce the sense of remoteness it conveyed, he noted, immediately after commenting on the portal, how alienated he was feeling from Arles's residents:

> Must I tell the truth, and add that the Zouaves, the brothels, the adorable little Arlésiennes going off to make their first communion, the priest in his surplice who looks like a dangerous rhinoceros, the absinthe drinkers, also seem to me like creatures from another world?

Vincent neither drew nor painted the entry to Saint-Trophime, only including its tower in his work as pilgrims would have seen it, from a distance, rising above the surrounding wetlands and meadows, disconnected from the structure that supports it. Still, his attraction to carvings from which he said he felt distant is undeniable. The oppositional terms he employed—*admirable* and *cruel, monstrous* and *beautiful*—recall the critique of carv-

ings that the Cistercian abbot, Bernard of Clairvaux, sent to his friend William, abbot of the Benedictine monastery of Saint-Thierry, in the second quarter of the twelfth century, when construction of the cathedral in Arles was underway. Bernard, who favored austerity in church decoration, referred to the depictions of contorted animal and human forms in the cloisters of his Benedictine brethren as "beautiful deformities," images that could entice and mislead monastic viewers and which were dangerous for that reason. His language, the product of rigorous rhetorical training, disclosed the disturbing appeal such sculptures had for him, prefiguring, without informing, Vincent's similar reaction to the portal.

Within two months, sunny weather provoked a change in Vincent's mood, replacing thoughts of the "Chinese nightmare" with a different vision. He now enthused over a view of the city "surrounded by a countryside entirely covered in yellow and purple flowers," saying, "That would really be a Japanese dream, you know" (see frontispiece).

THE ROAD TO REMEMBRANCE

In May 1889, a few days before moving to Saint-Rémy, Vincent sent Theo two crates of things, among which were paintings of what have since become landmarks: orchards and fields with the tower of Saint-Trophime in the distance; *Starry Night over the Rhône* (plate 6); a version of his bedroom in the yellow house; two images of *The Poet's Garden*; and two views he had done of the cemetery. He explained that flooding of the river while he was in the local hospital had resulted in intense humidity, causing the paint on one of the canvases to flake. For protection, he had attached bits of newspaper to its surface, regarding the picture of his bedroom as one of his best. He later asked Theo to return it to him so that he could copy it.

Within a few days, he had left Arles. The following January, a young poet and critic, Albert Aurier, published an appreciation of Vincent's work in the recently revived literary journal *Le Mercure de France*. He described Vincent's painting as "intense

and feverish," remarking on its "strange nature, that is at once entirely realistic, and yet almost supernatural.... It is matter and all of Nature frenetically contorted.... It is form, becoming nightmare; color, becoming flame." Vincent, initially disturbed by the attention Aurier's article drew to his work, was also flattered to have it written about. In early February, he wrote Aurier, thanking him for his remarks and offering to send him "a study of cypresses...on a summer's day when the mistral is blowing... as a memento of your article."

In July Vincent was dead. Slowly the world grew familiar with his painting. In 1895, the dealer Ambroise Vollard included a few of them in one of the first group shows of recent art that he mounted after arriving in Paris. In 1905, four hundred of the artist's works were put on display in Amsterdam's Stedelijk Museum through the agency of Vincent's sister-in-law. In 1908, Helene Kröller-Müller, the German-born wife of a Dutch shipping magnate, purchased the first of what would become dozens of Vincent's paintings for their eponymous museum in Otterlo. On this side of the Atlantic, eighteen of his canvases were included in the New York Armory Show in the winter of 1913, but it would take another two decades before his art attracted serious attention in the United States. The convergence of two events in the mid-1930s established the basis for Vincent's fame forever after.

The first was the publication of *Lust for Life*, Irving Stone's fictionalized biography of Vincent. Inspired by an exhibition of the artist's paintings in Paris in the late 1920s, the book was an instant best seller when it was published in 1934. In early November 1935, a large loan exhibition of Vincent's work, curated by Alfred H. Barr Jr., opened at the Museum of Modern Art in New York. A total of sixty-five paintings and sixty works

on paper, borrowed from European collections for the show, made it necessary for the museum to charge an admission fee of twenty-five cents every day except Monday and certain holidays to cover its costs. Following Eleanor Roosevelt's visit the day after the show opened, the museum decided to require an admission fee on Armistice Day, when entry to the exhibition should have been free, to control attendance; another free day was substituted for it. The exhibition's overwhelming popularity has been attributed to the inclusion of more than thirty drawings of Dutch peasants at work rather than to the forty-seven paintings done during Vincent's stay in Arles. Less familiar than the colorful landscapes and still lifes painted in Provence, the studies of people at work were praised as having the "vivid reality of certain Rembrandts" and found resonance, during an economic depression, with audiences experiencing hard times. In response to fifty requests to show Vincent's work, the loans were extended from six months to a year so that the exhibition could travel to additional cities. By the time it reached Chicago, the eighth of ten cities in which it was shown, in August 1936, nearly 640,000 people had seen it.

In one of several press releases, Barr acknowledged that books about Vincent's "sensational and unhappy life" had increased interest in his art, adding that the works would not have been written "had not van Gogh been first of all a great artist." Fifty years later his assessment was finally realized. Vincent's study of a patch of purple irises punctuated by a solitary white one, painted in the garden of the asylum at Saint-Rémy shortly after he moved there, in the spring of 1889, was sold at Sotheby's in 1987, and then resold three years later to the Getty Museum for what was then thought to be the highest price ever paid for a painting, although the sale price was not revealed (plate 7).

Its value had been foreseen by Theo at the outset. Shortly after receiving it, he told Vincent that he was including it, along with the one depicting a starry night over the Rhône, in the Independents' show in the fall, referring to it as "one of your good things," saying, "It's a fine study, full of air and life." The paintings were displayed alongside two seascapes by Seurat and two landscapes by Signac. In a review of the exhibition, the critic Félix Fénéon called Vincent "a diverting colorist even in eccentricities like his *Starry Night*,... [where] orange triangles are being swept away in the river, and near some moored boats strangely sinister beings hasten by." "His *Irises*," he said, "violently shred their purple parts over their lath-like leaves." In March 1990, an article in the *New York Times* referred to the Getty's recent purchase of Vincent's *Irises* as epitomizing "the extravagance of the booming art market." A century after an impoverished Vincent died prematurely, his paintings had become celebrated for their unprecedented monetary value.

During these decades, Arles abetted the surging interest in Vincent's work by making itself a travel destination, a place to which enthusiasts of his painting could come in search of sunflowers and cypress trees, the vegetation that inspired his depiction of "nature in the south." More recently, Vincent's association with Arles has been memorialized by a new building just outside the city's ancient walls, on land that previously belonged to the Parc des Ateliers, where railroad engines were constructed and serviced in Vincent's time. The structure, the tallest and most visible one in a newly formed center for research and experimentation in art, culture, and ecology, was designed by Frank Gehry to secure an identity with the region and its most celebrated artist (figure 14). Visitors to the structure see a video in which the architect refers to the building as a "constantly changing painting," for which, he says, he used the same light van Gogh painted.

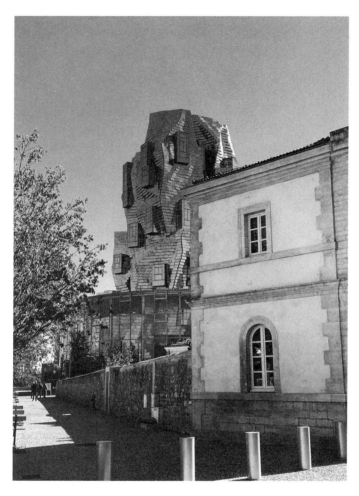

Figure 14. LUMA Arles Tower, designed by Frank Gehry. Photo by Kristen Bearse.

When Gehry embarked on the project, he cited local geological formations, as well as Vincent's brushstrokes, as elements he wanted the edifice's silhouette to evoke. The building's irregular upper surfaces were meant to suggest the outcroppings of the Chaîne des Alpilles, the low mountain ridge Vincent had seen from the train as it passed Tarascon on the way toward Arles,

{42} THE ROAD TO REMEMBRANCE

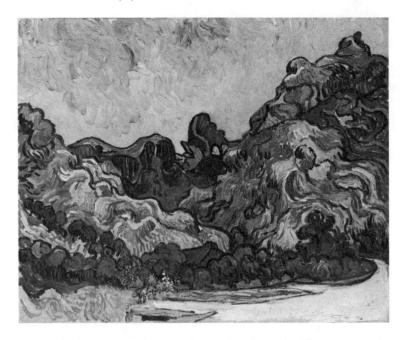

Figure 15. Vincent van Gogh, *Mountains at Saint-Rémy*, 1889. Oil on canvas, 72.8 × 92 cm (28$^{11}/_{16}$ × 36¼ in.). Thannhauser Collection, gift of Justin K. Thannhauser, 1978. Solomon R. Guggenheim Museum, New York. Image © The Solomon R. Guggenheim Foundation / Art Resource, NY

and which he described as "huge yellow rocks, oddly jumbled together, with the most imposing shapes" (figure 15). A British journalist, reviewing Gehry's early proposal in the *Financial Times* in 2010, remarked that the architect's interpretation looked like "a mongrel blend of giant scouring pads and crushed cars." As work progressed, modifications requested by local officials altered the design. Although the jaggedness of the upper portion of the structure remains its most dramatic feature, the boxlike projections have been tamed and the round base on which they sit, a reference to Arles's ancient arena (where Vincent went to

see bull fights), acknowledges the building's ancient surroundings. From a distance, the whole suggests a kaleidoscopic version of the domical mausoleum on the outskirts of Rome supposedly built to house the tomb of Emperor Constantine's daughter in the mid-fourth century.

Before the land was acquired for the new complex, it had been an abandoned rail yard and, before that, part of the celebrated cemetery known as the Alyscamps. Vincent and Gauguin had gone there to work at the end of October 1888. Gauguin, more interested in painting from memory than from nature, produced two canvases, each of which captured the edges of what remained of the burial ground. One showed a canal with a berm running alongside and the tower of a church in the distance; Gauguin called it *Landscape, or The Three Graces with the Temple of Venus* (figure 16). His other painting focused on the church at the end of the allée. Vincent, enthralled by the rows of slender, yellow-leafed poplar trees bordering the main path to the twelfth-century church of Saint-Honorat, rendered the scene twice, across its breadth as well as looking down it. He made two versions of the first view, which he referred to as *leaf-falls* (figure 17), and one of the second; sometime later, he made another version of this canvas.

In his letters, Vincent referred to "dark figurines of lovers" in one of the leaf-falls, and to "an old fellow and a fat woman, round as a ball," in another, allusions to the reputation the Alyscamps then had as a place where women of Arles went for their assignations. Recurrent remarks about brothels and illicit liaisons in his letters are often taken as evidence of Vincent's erotic preoccupations, but his commentary on these paintings in his letters to Theo indicates that his attention was focused more intently on the shapes and colors he saw in the cemetery.

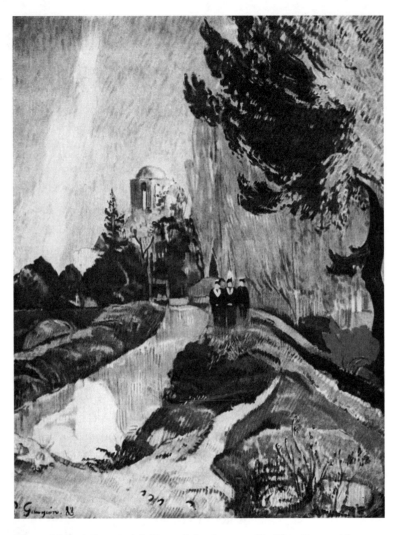

Figure 16. Paul Gauguin (1848–1903), *Landscape, or The Three Graces with the Temple of Venus*, 1888. Oil on canvas, 91.5 × 72.5 cm (36 × 28½ in.). Gift of Countess Vitali in memory of her brother Viscount Guy de Cholet, 1923, Musée d'Orsay, Paris.

THE ROAD TO REMEMBRANCE {45}

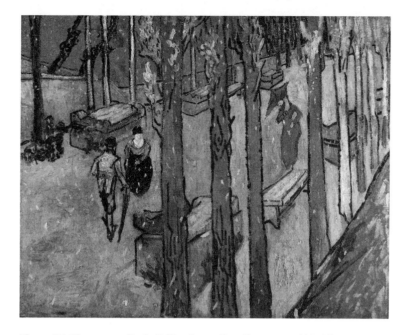

Figure 17. Vincent van Gogh, *Falling Leaves (Les Alyscamps)*, 1888. Oil on canvas, 72.8 × 91.9 cm (28⅔ × 36¹¹⁄₆₄ in.). Kröller-Müller Museum, Otterlo.

I think that you would like the leaf-fall that I've done. It [has] lilac poplar trunks cut by the frame where the leaves begin. These tree-trunks, like pillars, line an avenue where old Roman tombs colored lilac-blue are lined up to right and left. Now the ground is covered as if by a carpet with a thick layer of orange and yellow leaves—fallen. Some are still falling—like snowflakes.

His other version of the view down the walkway takes in the cemetery from a distance, placing the viewer slightly to the right, so that her line of sight moves obliquely across the path as well as down it, affording glimpses of land on the other side of the narrow canal through gaps in the trees (plate 1). Spaces

in the band of autumnal foliage are filled with a vignette of red-roofed industrial buildings and smoking chimneys shown rising behind and above a low gray wall. The structures had been built in the 1840s to support the needs of the new railroad. Long before construction of the sheds commenced, coffins remaining on the cemetery's site for centuries had been scattered, their removal erasing significant archeological evidence of the burials they commemorated. In medieval times, the cemetery had been famous for its multitude of tombs. Dante mentioned it in the *Inferno*, canto 9, without needing to give its name, remarking that sarcophagi, "near where the Rhône slackened its course," made the terrain there uneven. In the sixteenth century, when few if any pilgrims any longer visited the Alyscamps to pray for the souls of the dead, its tombs were coveted treasures. Documents record that a stone basin was brought from the cemetery to decorate the apartment in which the French king François I stayed during a visit to Arles in 1533. Three decades later, his grandson Charles IX (1560–74) sought to take a sarcophagus and some marble columns with him when he left the city after a visit, his effort failing when the boat carrying the antiquities reportedly sank a few miles upstream.

In these same years, engineers were canalizing the marshy area surrounding Arles in an attempt to direct water toward areas being farmed. This created the narrow Canal de Craponne through the southern part of the cemetery, cutting off a strip of the burial ground from the larger portion of terrain on which most of the tombs were situated and effectively reducing the Alyscamps to a slender sliver of land, at the far end of which stood a church that had been rebuilt in the twelfth century in honor of Saint Honoratus, one of Arles's early bishops (figure 18). Coffins were destroyed and dispersed, and the remains they contained were scattered.

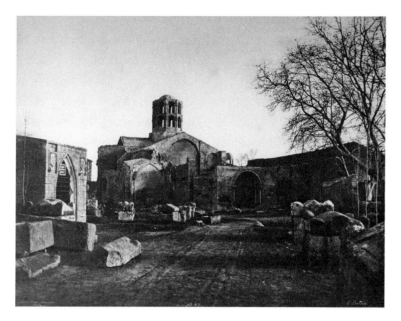

Figure 18. Édouard-Denis Baldus (1813–89), *Roman Cemetery (Alyscamps Necropolis and Church of Saint-Honorat, Arles)*, 1853–55. Salted paper print from a paper negative, 33.6 × 44.5 cm (13¼ × 17½ in.). Gift of Harriette and Noel Levine and Horace W. Goldsmith Fund through Robert B. Menschel. Museum of Modern Art, New York. Digital Image © Museum of Modern Art / SCALA / Art Resource, NY.

By the nineteenth century, when Prosper Mérimée observed people taking their Sunday strolls there, the more interesting sarcophagi that had once stood on the Alyscamps' grounds were stored in the former church of Sainte-Anne, across from Saint-Trophime on Arles's vast central square. Less ornate basins, Mérimée noted, were being used as drinking troughs on nearby farms, while abandoned lids formed bridges over slender waterways dividing properties throughout the area. Some sarcophagi had already been used to reinforce the borders of a central path through the remnant of the cemetery.

Shortly after Mérimée's visit, the land on the north side of

the little canal was ceded to the new railroad. Sheds built on the land on which sarcophagi had once stood were used for activities related to the maintenance of engines and railcars; for a time, these contributed substantially to Arles's prosperity. Vincent wandered through the yard and sketched the unprepossessing scene (figure 19). Henry James took note of the industrial intrusion when he visited the diminished cemetery a couple of decades later. His description echoes Vincent's portrayal of it in his painting of the Alyscamps (plate 1), with one noticeable difference:

> The meagre remnant of the old pagan place of sepulture ... now consists only of a melancholy avenue of cypresses lined with a succession of ancient sarcophagi, empty, mossy, and mutilated. An iron-foundry, or some horrible establishment which is conditioned upon tall chimneys and a noise of hammering and banging, has been established near at hand.

Had the ordinarily precise author failed to distinguish between the tall slender poplars and the occasional cypress that still marks the allée because their combined greenery muted distinctions, or was he recalling, when he sat down to write, what he had seen during travels elsewhere in Provence and in Italy, where cypresses customarily border cemeteries?

Like the painter, the railroad sheds had a short life. As new types of engines supplanted those being made there, several of the structures were shuttered. Beginning just after the First World War ended, and continuing in subsequent decades, what had once been an important example of industrial construction became outmoded, suffered decay, and was partially destroyed by fire. In 1984, the yard was finally closed. In its reincarnation as LUMA Arles, surviving sheds have been turned into pavilions

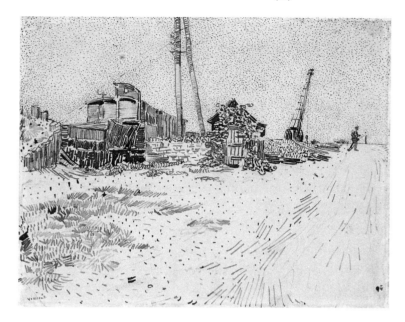

Figure 19. Vincent van Gogh, *Railway Storage Yard*, 1888. Pencil, pen, and reed pen and ink on paper, 24.2 cm × 32.0 cm (9½ × 12¹⁹⁄₃₂ in.). Van Gogh Museum, Amsterdam (Vincent van Gogh Foundation).

for display, converted into artists' studios, and adapted for dining. An ecologically planned garden covering a portion of the terrain is punctuated along its paths with occasional sculptures and environmental installations. A lush, grassy knoll's expanse hints, for those familiar with the site's history, at the vanished cemetery's original dimensions.

Those working inside the structures are protected from the searing sun Vincent included in many of his pictures as well as from the famously dry, windy climate which often interfered with his painting.

> When the mistral's blowing . . . it's the very opposite of a pleasant land here, because the mistral's really aggravating. But what a com-

pensation, what a compensation, when there's a day with no wind. What intensity of colors, what pure air, what serene vibrancy.

The strength of the mistral made Vincent place canvases flat on the ground and get down on his knees to paint. Alternatively, if the easel didn't stand firm in the wind, Vincent would fix it in the ground with iron pegs. "Nature seems to be in a rage," he wrote Theo, alluding to what he called the "nasty mistral," and noting, another time, that the "wild look" of some studies he was sending resulted from the force of the gales. Was he referring, one wonders, only to wind-blown sand in the paint on some of his canvases, or to the depictions of cypress trees Aurier described, in which branches are convulsed and needlelike leaves appear to be shaking?

Vincent's awareness of the downside of the weather had made him warn Gauguin about it, suggesting that he might want to wait to come south. "Perhaps you'll be disillusioned with Arles if you come at a time when the mistral's blowing," he wrote, "but wait . . . It's in the long term that the poetry down here soaks in." Gauguin didn't remain in Arles long enough to discover its poetry, and decades passed before others would recognize it in Vincent's paintings.

"A LITTLE ROME OF GAUL"

Traces Vincent left, both real and re-created, draw visitors in the way that the remains of another era's designated holy men lured travelers long ago. When the *Pilgrim's Guide* was written, in the twelfth century, the city was identified as the first stop in a devotional journey ending in the northwestern corner of Iberia, where the remains of the apostle James the Great were enshrined. Journeying from one site to another propelled pilgrims back in time, immersing them in events and connecting them to individuals whose stories had been written long before.

The earliest traveler through the region was Herakles. He makes a brief appearance as a denizen of the underworld in Homer's *Odyssey*, thought to have been composed in the decades around 700 BCE, but is better known to us as the protagonist of a series of labors circulating in later centuries. His feats of bravery, accomplished in various places around the Mediterranean, included a voyage to the Iberian Peninsula to capture the

giant Geryon's cattle. The Greek hero's journey home with the beasts brought him through, or near, the coast of Gaul, where "remembrances" of his travels survive to this day in sculpture and in several place-names. Attempts to establish the route he traveled with the cattle end in failure because the story is fictive, but details linking it to specific places give it life. The stories of Herakles's journeying provided a mythic precedent for the activities of sailors from the coast of Asia Minor who settled along the northwestern shoreline of the Mediterranean during the seventh century BCE, establishing a port at a place they called Massalia. Significant vestiges of their settlement exist in an archeological park close to Marseille's waterfront. Its remains were discovered when occupying forces dynamited the area in 1943, in what was termed at the time a necessary military operation.

During the third century BCE, Romans made serious inroads in the region, taking over Greek encampments and pushing back against Celtic tribes living in the area. Some three hundred years later, Roman soldiers, eager to penetrate territory away from the Mediterranean coast, took over a settlement at the bend in the Rhône. The name they gave it, Arelate, reclaimed an earlier Celtic designation identifying the place as lying near water. In the spring of 49 BCE, a few wooden boats hastily refitted in the city's port enabled forces loyal to Julius Caesar to defeat those associated with Pompey in one of their many maritime battles for the leadership of Rome; the victorious general recounted the event in his *Commentaries on the Civil War* (2.1–6). As a show of gratitude for the city's assistance, he granted it the status of a Roman colony three years later. The declaration established Roman jurisdiction in the surrounding territory and subsequently provided veterans of the Sixth Legion, who had fought for Caesar, with confiscated land on which

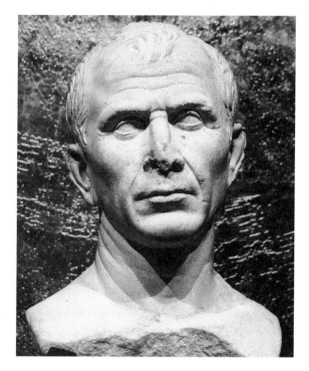

Figure 20. Marble bust said to be of Julius Caesar, found in the *Rhône* in Arles in 2007. IRPA. Musée Arles Antique. Photo by Wikimedia Commons user Mcleclat (CC BY-SA 3.0), creativecommons.org/licenses/by-sa/3.0/legalcode.

to establish their fortunes. An important source of wealth for them and for Arles's residents for centuries thereafter would come from the cultivation of animals on the fertile marshland of the river's delta.

Memory of the naval battle was resuscitated in the fall of 2007, when an exceptionally well-preserved marble head was retrieved from the Rhône close to its western embankment (figure 20). The sculpture's furrowed brow, emphatically defined cheeks, and receding hairline suggested to the underwater archeologists

who found the carving that it might be a portrait of the legendary general. When the discovery was officially announced in May of the following year, attention was drawn to the head's resemblance to a few other Roman-era sculptures said to depict the conqueror of Gaul. The images with which it was compared display features mentioned in the description that the Roman historian Suetonius included in a series of biographies about the first twelve emperors (*De vita Caesarum*). This text, composed more than a century and a half after Caesar's death, describes him as having piercing eyes and a full face, and notes his habit of combing his thinning hair forward from the crown of his head to obscure the baldness said to be a source of embarrassment for him. Suetonius's description, likely based on one or another representation made of the general after his assassination, conveys a sense of Caesar's vanity as much as his hair loss. The latter, a defining aspect of his image, is depicted on the sculpture found in the riverbed.

Scholars of ancient art argued their divergent responses to the carving in the immediate aftermath of its discovery, with discussion dividing along national as well as theoretical lines. German and British scholars agreed only to a hypothetical attribution, because the work lacked any inscription, even though such a text would not be fully probative: words can present something as true even when it is not, especially when written in the aftermath of an event (or an individual's demise). The French, citing contextual evidence, eagerly accepted the bust as a representation of Caesar. In addition to the suggestive nature of the find site, the imported material in which the head was carved indicated celebration of a noteworthy individual.

The significance of Caesar's local triumph should not be slighted. The status he held as the veritable father of Arles lends

credibility to the notion that a likeness of him had once belonged to a civic embellishment of the city. The archeologists who found the head suggested that it had been part of a short-lived high-relief display commemorating the defeat of Pompey. The head is flattened on its back, suggesting that it had been attached to a large plaque. Its excellent condition indicates that it was deposited in the river not too many years after it was made, undoubtedly after Caesar's death, and protected for two millennia by the mud in which it was immersed. Installed now in the local museum of antiquities, where it is cautiously identified as a presumed portrait of Caesar, it quickens connections between the remoteness of written history and the reality of material fact, giving new life to the story of Caesar's conquests that students studying Latin still read. Vincent was one of them. He studied both Latin and Greek while living in Amsterdam in 1877–78, in preparation for the theological training he was intending to pursue. In one of his letters, he remarked on the difficulty he was having with an assignment translating an unidentified passage from Caesar's writings.

The Rhône is a formidable river and Arles's crescent-shaped harbor, situated close to its mouth, controls its waters. Vincent's sketches of its riverbanks and his celebrated painting of its port under a canopy of stars have rendered it familiar to those who have never seen it (figure 21). The leader of the team involved in the discovery of the ancient head remarked that the river's current "always runs in the same direction" and that its waters have a remarkable ability to preserve wood, limestone, and marble "better than any sea." The way the underwater archeologist marveled at the constant flow of boats and fish recalls the admiring account written at the beginning of the first millennium by the ancient historian Strabo, who extolled the river's size, its rapid

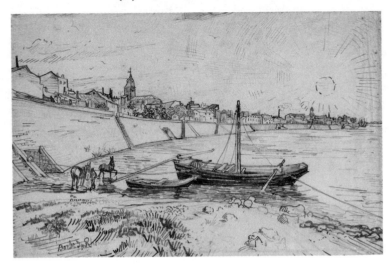

Figure 21. Vincent van Gogh, *View of Arles on the River Rhône* (Provence-Alpes-Côte d'Azur region, France), ca. 1888. Pen and brush and brown (originally violet) aniline ink, 39.5 x 61.0 cm (15½ x 24 in.). Museum Boijmans Van Beuningen, Rotterdam. Donation: Herman van Beek & Han Nijgh, 1929 / Photo: Studio Buitenhof.

descent from the Alps, and the number of tributaries flowing into it. The Rhône, Strabo remarked in his *Geographika*, was navigable through some of Gaul's richest provinces, making Arles's position near its mouth a center for trade and passage. When its rushing waters made travel on it difficult, merchants were forced to transport wares in wagons on roads running alongside the waterway.

The river's turbulence has played a prominent role at various moments in Arles's history. According to legend, the early fourth-century Christian convert Genesius attempted to escape his Roman captors by jumping into the Rhône. After he was pulled from the waters and beheaded on an embankment slightly upstream from the city, the river abetted distribution of his body

parts. His head was swept out to sea on a voyage bringing it to Cartagena, where it engendered observances in the saint's honor along Spain's southeastern coast. His body, transported by the waters of the Rhône around the city, was buried in the Alyscamps; devotional rituals soon developed there around his remains.

Trinquetaille is the name of the section of Arles where Genesius was beheaded. It was inhabited by Romans at an early date, with portions of it becoming a burial ground from which imposing sarcophagi have been extracted. Christian pilgrims who went there to venerate Genesius took away with them bits of bark and branches from a mulberry tree growing nearby, believing that these fragments had the power to heal. As late as the twelfth century, the column to which he was believed to have been bound was described as stained with his blood. More likely, the tall shaft that the *Pilgrim's Guide* instructed pious travelers to visit was made of naturally streaked marble and had once belonged to a splendidly decorated ancient building located on or near the site of Genesius's martyrdom.

Processions crossing the bridge between the riverbank where Genesius died and the portion of Arles containing the cemetery where his remains were entombed honored both his blood and his body. Participants experienced their physical movement as symbolic unification of the saint's severed parts and the city's distinct sections. Whether or not stories like the one of his decapitation were true, they inspired the telling of compelling tales. Ausonius, the poet and teacher from Bordeaux who served Emperors Valentinian and Gratian in various positions during their successive reigns (364–83), noted that a pontoon bridge made of boats spanning the Rhône facilitated visits to the twin places of Genesius's remembrance. Sometime in the fifth cen-

tury, the crowd's weight during a procession on the saint's feast day caused the bridge to collapse. Honoratus, bishop at the time, successfully implored Genesius to save those tossed about by the waters. The story of their salvation was reported a century later by Gregory of Tours.

Around 1200, Gervase of Tilbury, an English canon lawyer residing in Arles, wrote a compendium of worldly facts and lore in which he paid tribute to another role the river had played in earlier times. His *Otia imperialia*, a book of popular stories written for the enjoyment of the future Holy Roman emperor Otto IV, in whose circle he traveled, claimed that coffins had once been floated down the Rhône on their way to Arles's celebrated cemetery with a coin on top to pay for passage. When the boxes lodged in the mud close to the city's shoreline, gravediggers carried them to the necropolis; coffins lacking coins would be left behind. The story has the tombs replicating the trip that souls took to the underworld in Greco-Roman mythology, in which a coin had to be paid to boatmen for passage across the river Styx. It alerts us to the mystique the Alyscamps retained in the medieval imagination as a mythical place of burial.

In 121 BCE, Rome established its first administrative entity in Gaul. It encompassed land stretching from the Italian frontier to the Pyrenees, including the river's broad delta, with its important access to the sea. A thousand years later, long after the Roman Empire had fallen, and the mouth of the Rhône had silted up, the river constituted the boundary between rival medieval powers. The modern designation Provence, which evolved from the original Latin name for the region, Provincia, recalls the region's ancient roots, although it identifies only half of the original expanse, the portion of the former Roman province lying east of the Rhône. For strategic reasons, Rome estab-

lished the capital of this territory in its western portion, close to the Spanish border, at an existing settlement at the mouth of the Aude River; Narbo Martius (Narbonne) was elevated to the status of Roman colony in 118 BCE. Two roads, built around this time by the general Gnaeus Domitius Ahenobarbus, reinforced that city's critical geographical position. The Via Domitia descended from the mountainous border with Switzerland, traversed southern France, and passed through Narbo Martius before penetrating Spain. According to legend, this was the route that Herakles followed on his return from the Iberian Peninsula. Another second-century road, the Via Aquitania, exited Narbo Martius on a westward course through Tolosa (Toulouse), reaching the Atlantic coast at Bordigalia (Bordeaux).

Until 2016, the portion of the Roman province extending from the western banks of the Rhône to the Pyrenees constituted two administrative regions of France, Languedoc-Roussillon and Midi-Pyrénées. The appellations commemorated the territorial boundaries of the lords contesting power in the area in the Middle Ages. Merger of the regions under a new name, Occitanie, with its prefecture in Toulouse, emphasizes ties with the counts of Toulouse and the culture of their court in the twelfth and thirteenth centuries. Protesters of the reorganization were quick to point out that the new nomenclature obscured the vestiges of Catalan heritage that linger along the southernmost portion of France's Mediterranean coastline, drawing attention to the critical role language and culture play in establishing and maintaining identity.

Under Caesar's great-nephew, adopted son, and heir, an extensive building program gave a powerful visual dimension to an agenda of political subjugation and stabilization. Some historians date the beginning of this so-called Augustan Age to

Octavian's defeat of Antony and Cleopatra at Actium, in 31 BCE, four years before the Senate voted him the honorific name Augustus, by which he has been known ever since. An initial feature of his plan for the enhancement of recently acquired terrain involved expansion of the network of roads providing Rome with access to the portions of Gaul that Caesar had subdued. Several of the new roads intersected near Arles. The Via Julia Augusta continued the trajectory of the Via Aurelia, which had been built in the middle of the third century BCE as a link between Rome and lands to its north. The new portion, absorbed long ago into the earlier road's identity, approached Arles from the southeast, passed through a monumental gateway, and brought travelers out of the city on its northwestern side. Not far away, at Nîmes, connection could be made to the Via Domitia, enabling passage southward to Spain and eastward toward the Alps. Another road led due north from Arles, paralleling the course of the river. It was named for Agrippa, Augustus's friend and later family member, an able general and consummate engineer. Further up the Rhône, at Lyon, additional routes diverged, veering west toward Rome's newer Gallic provinces.

This network of roads formed the basis for later travel, even as portions were submerged beneath regional growth. Finds of original paving stones regularly occur in unexpected places—in the middle of abandoned fields as well as in the center of cities. A verdant park beside the Rhône in Vienne, north of Arles, preserves vestiges of the Via Agrippa; other portions of it are buried beneath the busy docks not far away. A public square, outside the former archbishop's palace in Narbonne and close to the cathedral, enshrines, at its center, paving stones from the section of the Via Domitia that passed through the heart of the city. This piece of the past has been turned into a public seating

area. A mosaic ledge framing the preserved section of pavement serves as a bench for those who want to linger on its edge; a short set of steps descending to the original level of the road allows access to the archeological remains for those wishing to inspect them.

Southeast of Arles, on a spur of the Via Aurelia leading toward Marseille, a modest bridge testifies to the level of architectural refinement that flourished under Augustus (figure 22). The structure was built between 20 and 10 BCE on the edge of a large pond as the road crossed the Touloubre River near the village of Saint-Chamas; it is believed to have provided access to a family tomb. An inscription, immediately beneath the cornice on the outer face of one of its arches, identifies the patron of the project as Lucius Donnius Flavos, a priest of Rome and Augustus. The bridge, referred to as the Pont Flavien after the individual in whose memory it was built, is not to be confused with work of the Flavian dynasty ruling the empire nearly a century later.

A pair of freestanding arches frames the passage across the bridge's short span, transforming the crossing of a muddy stream, which may once have served as a boundary, into a ritualized course of movement. Fluted decoration on the upright forms, restrained but repetitious, connects to work done elsewhere during Augustus's reign, sowing seeds for widespread recognition of his accomplishments. The bridge, though damaged and repaired, remained in use until 1944, when a speeding US Army truck knocked it down. American workers reassembled it with the original stones, but it is no longer used for rotary passage. Nowadays, a modest structure nearby enables the crossing of what has become a tiny rivulet.

Augustus embellished certain settlements with meeting

Figure 22. Pont Flavien, Roman bridge in Saint-Chamas, France. Photo by Flickr user maarjaara; uploaded to Wikimedia Commons (CC BY 2.0), https://creativecommons.org/licenses/by/2.0/legalcode.

halls and places for performance, surrounding them with massive walls that were more aspirational than defensive. Arles's imposing wall stood on a rocky outcropping on the settlement's eastern perimeter. At the point at which the Roman Via Aurelia entered the city, a gateway similar to the Porte d'Auguste in Nîmes provided passage for twin lanes of traffic; sizable portions of its stonework remain in place. Around 25 BCE, a large forum was built on land marking the beginning of the upward slope; a U-shaped arrangement of vast vaulted underground corridors enabled construction of the colonnaded galleries above. This subterranean cryptoporticus remains intact, evidence of Roman engineers' clever adaptation of the uneven contours of

the local landscape. In recent decades, it has been reopened as part of an ongoing effort to recuperate Arles's ancient past and educate the public about the city's place in France's monumental patrimony.

The sole surviving aboveground portion of this once massive construction is a pair of columns surmounted by a gable close to the corner of a building on the Place du Forum (figure 23). Prosper Mérimée took note of the ancient remnants during his visit in the 1830s, speculating that the columns belonged to a reconstruction during the early years of Christianity in which elements from an earlier temple were reutilized. The frieze above the columns carries the remains of a dedicatory inscription, associated with Constantine based on marks left by the lost letters' metal fastenings. Although the claim is disputed, archeological investigation indicates that the structure was indeed added to an earlier building in the fourth century, testimony of the continued use of Arles's urban center into the Christian period; something similar was occurring at the same time at numerous sites around the Mediterranean.

The forum bordered the *cardo*, the main north–south street of the city, and was in alignment with the smaller cross street, the *decumanus*. In about 12 BCE, an impressive theater was constructed toward the eastern end of this axis, on the summit of the hill. With its diameter of over one hundred meters, it could have accommodated ten thousand spectators. Nearly a century later, circa 80 CE, an amphitheater (arena) was built near the theater, introducing another one of Rome's architectural inventions to Arles's center; a piece of the Augustan wall had to be destroyed to accommodate its vast size. With a capacity of twenty to thirty thousand spectators, it represented the prowess of the Flavian emperors in the same way that the walls and theater

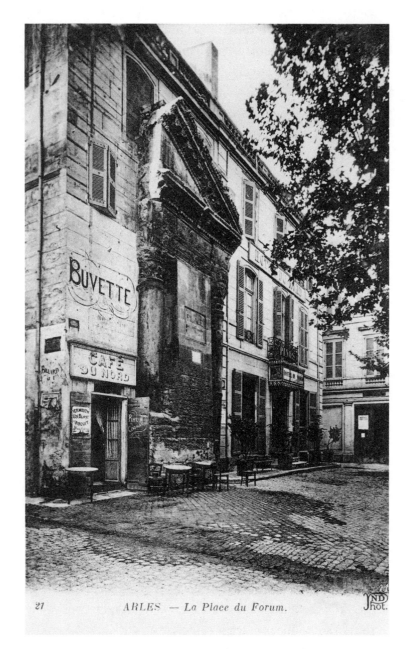

Figure 23. Place du Forum, Arles (postcard). Ingalls Library. Courtesy of the Cleveland Museum of Art.

Augustus had built projected a compelling image of his authority wherever they were constructed. At various times between the late third and the fifth centuries, the aging wall around the city was repaired and its contours redrawn to accommodate transformations in urban life then occurring throughout Gaul. Cities were shrinking and new needs were emerging; changes in the material composition and extent of Arles's fortifications record those realities. An inner wall, rebuilt at an uncertain time, reduced the city's footprint on its southern side, skirting the theater and incorporating a portion of that structure's three-story elevation into its fabric. An isolated rectangular bay provided a lookout over sloping land to the south; its designation as the Tour de Roland refers to a ninth-century bishop.

Close to the Rhône stood additional monuments. Near the northern portion of the city's wall was a pontoon bridge across the Rhône. A "muddy" arch, so called because of its situation along the shore, was decorated with depictions of military paraphernalia paying tribute to campaigns waged by the local colony of veterans in eastern parts of Europe. The reliefs were documented in drawings made before the arch was destroyed, in the seventeenth century. Further downstream was a circus. Built in the second century and encumbered with dwellings along its perimeter by the end of the fourth, it continued as a place for competitions into the mid-fifth century. Today, the Musée de l'Arles et de la Provence Antique, with its carefully curated displays of artifacts and sculptures (including the bust of Caesar), stands on the site where spectacles of a different sort formerly entertained the public. Inside, models of what Arles looked like capture, in miniature, the imposing imperial character the city once had, before effects of deterioration severely diminished its marble-clad monuments.

According to several sources, all legendary, a group of missionaries sent from Rome toward the middle of the third century evangelized Gallia Narbonensis, the name Augustus had given to Provincia. They established themselves in important cities, converting pagans, becoming bishops, and dying in the places in which they settled. Saturninus went to Toulouse, Paulus to Narbonne, Daphnus to Vienne, and Trophimus to Arles. This city's proximity to the Mediterranean and the protection its site offered territories further inland contributed to its continuing importance. In 314, Constantine, the first Christian emperor, organized a church council in Arles at which Donatism, a burgeoning heresy named after the bishop of Carthage, was condemned. It threatened the new religion's unity by demanding a degree of moral purity that priests who had been forced to espouse compromising positions during Diocletian's persecutions could not meet. Despite the council's actions, the heresy was not eliminated; popular support for it continued for some time thereafter in North Africa.

Although Constantine built a residence and established a mint in the city, material evidence of his presence in Arles is associated primarily with the substantial ruins of a large brick-and-limestone structure, north of where the forum stood, close to the riverbank. Lofty vaults rising over numerous chambers identify the remains as that of a grand bathhouse; in the later Middle Ages, legends perpetuated association of the ruins with the counts of Provence, whose residence it was said to have been. After Constantine's death, in 337, his sons divided the empire into four provinces, one of which was Gaul. Around 400, the seat of the province's governing prefecture was moved from Trier to Arles, effectively making the city the regional capital. Foundations of a vast basilica immediately south of the baths may

belong to the structure built for the relocated prefecture. Its imposing measurements, twenty meters wide by fifty-eight meters long, approach those of the Aula Palatina (26 m x 67 m), the hall Constantine had built early in the fourth century in Trier, when that city served as the center of his activities.

In 417, Pope Zosimus transferred religious primacy from Vienne, a city a hundred and fifty miles upstream, to the one at the mouth of the Rhône, further elevating Arles's status by making it the most powerful bishopric within the religious province. This prominence was acknowledged sometime thereafter by the relocation of the cathedral from a site near the wall's southeastern corner, where it had been built in the mid-fourth century, when other cities were also constructing their first episcopal foundations. The new site was close to the enclosure housing the theater, "fully in the ancient city," as one French archeologist put it.

Hilarius, bishop between 429 and 449, had likely made the decision to reposition the building. According to an anecdote in the story of his life, an accident occurred when some decorative pieces of marble being removed from the theater's proscenium for use in the construction of "basilicas" fell on the foot of a deacon named Cyril, seriously injuring him. Scholars understand the text as referring to the building of the new cathedral. Such reports of accidents or other mishaps were often buried within stories about holy men to dramatize dangers and enhance perception of their ability to heal or avert disaster. Over time, the anecdotes resonated with more or less relevance, according to a community's needs. In the early centuries of Christianity, when theaters were viewed as sites of temptation, the reference to falling pieces of marble would have cautioned readers and listeners about harmful power

emanating from the tainted stones. The dangers extended to those who worked in such buildings. According to the fifth canon issued by the council held in Arles in the early fourth century, actors pursuing their profession were to be excluded from membership in the (religious) community.

Enduring evidence of Christian integration into the fabric of the Roman city survives in the Alyscamps, the necropolis Romans built along the Via Aurelia as it approached Arles from the southeast. During the fourth century, Christians, here and elsewhere, had begun to bury their distinguished dead in splendid tombs, as the Romans had already been doing, using reutilized coffins made of marble as well as newly carved ones of comparable splendor. The most highly desired sites for burial were located near the bodies of holy men who had suffered because of their efforts to spread the faith. Documents mention the presence of entombments around the grave of Genesius a few decades after his death; a century later Bishop Hilarius's remains were buried near those of the early martyr in a reused sarcophagus.

Late in the fourth century, Ausonius referred to Arles as "gallula Roma Arelas," a little Rome of Gaul, placing it ahead of Toulouse, Narbonne, and Bordeaux, because of its array of marble-clad monuments. Over the course of the centuries, several of these structures were converted into habitations. Others were looted for their splendid materials but did not become unrecognizable and were seldom willfully destroyed. Records report their widespread adaptation and reuse in numerous places in an era when demolition was not (yet) an easy option for structures in stone. Arles's arena is emblematic of such reuse. In the twelfth century, towers were added to it for the protection of those who dwelled within its arcaded walls. As late as 1825, when

Figure 24. Jacques Peytret, *Arles Amphitheater as It Is, at Present*, 1666. Etching and burin, 34.5 cm × 45 cm (13¹⁹⁄₃₂ × 17¹¹⁄₁₆ in.). Source: gallica.bnf.fr / Bibliothèque nationale de France.

its dwellers were finally sent away, 212 houses and two chapels remained inside the first-century construction; continuous habitation had assured its survival (figure 24).

By the time Henry James visited in the late 1800s, only the arena was still intact; the forum and the circus were gone, and the theater was in ruins. Structures that had once earned Arles tenth place among twenty cities, according to Ausonius's rankings, no longer provided passersby with a sense of the city's illustrious history (figures 25 and 26).

Even memories of what the American author had seen on a previous visit had grown elusive.

Figure 25. Amphitheater in Arles, ca. 1860. Stereoscopic photograph (author unknown), 8.6 × 17.4 cm (3^{25}⁄$_{64}$ × 6^{27}⁄$_{32}$ in.). Rijksmuseum, Amsterdam.

Figure 26. The Roman theater in Arles, 1883. Part of a group of travel photos purchased by Johanna Wallis Kempe between August and December 1883. Hallwyl Museum, Stockholm.

I had been to Arles before, years ago, and it seemed to me that I remembered finding on the banks of the stream some sort of picture. I think that on the evening of which I speak there was a watery moon, which seemed to me would light up the past as well as the present. But I found no picture ... At last I arrived at a kind of embankment where I could see the great mud-colored stream slipping along in the soundless darkness.... It was not what I had looked for; what I had looked for was in the irrecoverable past.

THE PORTAL
AND ITS PAST

In the eyes of many coming to Arles now, the splendor of the city's ancient sites has receded behind places reifying Vincent's presence. My curiosity about the land on which the city's cathedral was rebuilt in the twelfth century paralleled Vincent's obsession with Japan, a place he had never seen but could imagine. The model of ancient Arles in the museum of antiquities shows the easternmost portion of the earlier church occupying land adjacent to the site on which the structure containing the theater's stage once stood. How much of this building remained in place around 1100, when the bishop of Arles launched an ambitious campaign to build a new cathedral, cannot be known, but extant evidence of aboveground and subterranean remains in the vicinity of Saint-Trophime indicates that more residue from the city's Roman past remained visible for longer than we have imagined. When the portal was erected, its footings were positioned on huge stone blocks belonging to an earlier build-

ing. Prosper Mérimée suggested that they had been part of the early fifth-century palace of the prefecture, a claim that has not been substantiated. Elements of that structure are believed to lie further west, close to the remains of the baths. More likely the portal rests on remains of the earlier church. So much ancient debris still cluttered the area around the portal, Mérimée said, that a mere shaking of the ground exposed buried fragments. A half century later, the Roman fragments dotting Arles's center and cluttering the nearby church of Sainte-Anne, where many had been deposited, contributed to Vincent's perception of Saint-Trophime's portal as recalling "the glorious world of Nero the Roman."

The new, vaulted building was dedicated to Trophimus, the purported third-century evangelizer of Gaul, and Arles's legendary first bishop, whose relics were first mentioned as belonging to the church in the late tenth century. In 1152, when work on the cathedral would have been sufficiently complete in its eastern portions to allow the choir and crypt to accept relics, the saint's body was ceremonially brought into its new home. Burial of the city's archbishops near his remains began shortly thereafter. The new church amply served the needs of the community until the later decades of the fifteenth century, when the apse was demolished and replaced by a spacious construction built in accordance with contemporary taste. The large crypt, in which Trophimus's relics and those of other holy men had (presumably) been placed, disappeared during that campaign.

Identification of the cathedral with the city's first bishop signaled engagement with Arles's venerable past, something that was occurring at churches elsewhere in France in the early decades of the twelfth century. At the cathedral of Autun in Burgundy, the claim that the diocese possessed the remains of

Lazarus of Bethany was accompanied, in the 1130s, by construction of a new church for displaying his relics. A few years before, the monastic community at nearby Vézelay asserted that Mary Magdalene's bones had been brought to the hillside abbey from the cave in Provence in which she had died at some point in the past. Accounts of the lives of Lazarus and Mary Magdalene are contradictory, concurring, primarily, in their affirmation of the presence of two of Jesus's followers on Gallic soil after flight from persecution in the Holy Land. The remains of these individuals, like those of James in Compostela and Peter in Rome, brought foundational figures in the story of Christianity to lands along the western shores of the Mediterranean. From the perspective of the twelfth century, Trophimus belonged to that early era's history.

The facade of the church stood immediately across from a corner of the forum. In the seventeenth century, a handsome city hall was erected over the southern portion of the underground passages that had supported the ancient structure. The subterranean chambers preserve the plan and memory of the building in which residents of Arles were still attending to matters pertaining to business or legal affairs as late as the early sixth century. Caesarius, bishop of Arles at the time, incorporated pleas into his sermons for parishioners not to leave the church in pursuit of secular activities (likely taking place in the forum) before celebration of the Mass had been completed. Although the present civic building hides from view evidence of its predecessor, aboveground remains of one of the forum's entries persists a few short streets away, diagonally across from the café Vincent painted at night, the canvas's dark starry sky recalling representations of the firmament he had seen in pictures of the calendar pages in the Duc de Berry's favorite book (plate 8).

In Vincent's time, the place was called Café de Boeuf, and was referred to by locals as Arles's little stock exchange, because of commercial discussions in which its patrons engaged. When the café closed, a shop took over the premises. Relatively recently, the terrace was painted yellow, and an establishment known as both Café la Nuit and Café Van Gogh was reintroduced to the site, unambiguous evocation of the scene Vincent captured in mid-September 1888. Astronomical calculations identify the configuration of the night sky in his painting as correctly displaying the constellations seen in Arles on the nights of September 16 or 17. A few days earlier he had written his sister and brother that he was working on a view of the exterior of a café, calling it "a painting of a night without black," and noting the risk of mistaking colors in the low light. "I may take a blue for a green in the dark, a blue lilac for a pink lilac, since you can't make out the nature of the tone clearly," he explained to Willemien. The painting is an arrangement of different shades of blue surrounding the bright yellow exterior of the building housing the café. Green branches of a lofty conifer catch some of the light from the lamp over the terrace but the tree from which they emerge is out of sight. Hidden behind the branches are monumental remnants of a portico consisting of two granite columns surmounted by a lushly carved gable (see figure 23).

The building in which the remains are embedded was (and still is) a hotel. Henry James stayed there during one of his visits to Arles, noting in his diary that he chose it over the plainer one next door because of its exceptional ornamentation. Souvenir-seeking tourists photographing the Place du Forum from the corner on which Vincent stood while painting may not notice the remnants of Arles's history diagonally across from them. The ancient shafts do not figure in Vincent's composition and

discussions of the painting do not comment on their absence. When they are discovered, the visitor wonders whether Vincent had failed to take note of them in the darkness, or deliberately left them out of his composition to focus on the luminous effects he was intent on capturing.

Nearly a third of Vincent's canvas is devoted to the street surrounding the square, its irregular stones dappled with flickering light from the café's lamp, as though they had recently been moistened by rain. Four years before, Henry James had reacted differently to the hotel's surroundings, calling the square "ill-proportioned . . . and given over to puddles and shabby cafés." The cobblestone streets seemed "torturous and featureless" to him, full of "villainous little sharp stones" that made exercise "penitential." The place had not changed, only its visitor had. One took in the scene with his eyes while the other recalled how it felt to make his way along its streets.

Another marker of Arles's past had not yet been put in place on the square when Vincent painted it. In 1909, a statue of Frédéric Mistral, noted writer, philologist, and Nobel laureate (1904), was erected close to the columns (figure 27). The plaque on its base reports that the original bronze figure was removed in March 1942, at the request of the Vichy government, to provide metal for German weapons. The decision to destroy the statue countered the Vichy government's espousal of regional initiatives and was viewed by many at the time as an assault on local identity. In 1948, the present statue, made at a foundry in Marseille from a plaster cast of the original, was restored to its position of honor in a celebration recalling the one accompanying the monument's inauguration forty years before. The swift restitution of the image demonstrated the city's desire to reestablish its traditional identity in the aftermath of an occupation

Figure 27. Statue of Frédéric Mistral on the Place du Forum in Arles. Théodore Louis Auguste Rivière, sculptor. Original 1909; destroyed 1942; reconstituted 1948. Bronze. Photo by Wikimedia Commons user Finoskov (CC BY-SA 3.0), https://creativecommons.org/licenses/by-sa/3.0/legalcode.

known to this day for the painful compromises it extracted from the region's residents.

Mistral's writings emphasized Provençal language and myths, cultural markers with which the postwar community sought to reidentify. Vincent was an admirer of Mistral's work, mentioning in his letters that he had read fragments of the poet's most famous work, the epic poem *Mirèio*, in a French translation, and knew of Gounod's opera *Mireille*, which was based on it. The tragic love story, set in and around Arles, recounts the thwarted romance between a wealthy young girl and a penniless peasant named Vincent (!). The painter regarded his own affection for Provence

as aligning with that of the Félibres, the literary group to which Mistral belonged, telling Theo that, with the Félibres "loving Provence as whole-heartedly as they do, I perhaps have a right to their interest." It is not clear that he ever got their attention.

Attachment to regional identity has long played a vital role in France's national narrative, reemerging, with renewed fervor, in the years after the Second World War. The Museon Arlaten, founded by Mistral in the mid-1890s and relocated a decade later to a sixteenth-century building (built over Roman ruins) close to the square on which his statue stands, promoted nostalgia for Provence's past with its large dioramas of local celebrations and displays of costumes and artisanal materials in smaller vitrines. The building's recent renovation has updated that vision, hinting at what Arles is in the process of becoming, not just what it once was. Traditional static displays now share space with state-of-the-art costume exhibits, interactive demonstrations, and changing multimedia installations. An early twentieth-century ethnographic museum's presentation of a timeless past is presented as part of the building's, as well as the region's, ongoing history, with newly created spaces documenting current traditions in freshly imagined ways.

The portal's installation in front of the western entrance to the cathedral was conceived with a no less deliberate but vastly different effect in mind. Instead of updating the Roman ambience of the city's center, the richly carved ensemble of architectural elements and relief carvings embraced, even imitated, what was already there. The crisp shape of the gable fashioned by masons for the summit of the entry engaged what remained of the forum's porticos on the other side of the road, connecting the portal to its ancient environs and reinforcing the claims of antiquity that the relics inside the church asserted.

As the Roman buildings deteriorated and undistinguished new ones filled in the spaces where they once stood, the portal's connection to its setting and the epoch it evoked vanished, making it difficult, and ultimately impossible, for visitors to see the twelfth-century portal as contemporary ones would have done, as a structure in dialogue with its neighbors. Deprived of that association, the richly carved entry, which advances from the patchy stonework of the church's facade, looks forlorn, like something salvaged and then set down in unfamiliar surroundings. Its appearance has made me wonder whether twelfth-century masons might have wanted the portal to look like a remnant. By differentiating its material and architectural elements so starkly from the wall behind it, the builders enhanced the impression that the entry had belonged to another (older) structure.

Henry James saw it differently. He missed the portal's connections to Arles's past, saying that its "apostolic sculpture" struck a "false note" in the otherwise pagan city. Nonetheless, he was impressed with the "wonderful Romanesque porch," describing it as "a dense embroidery of sculpture, black with time, but as uninjured as if it had been kept under glass." Fifty years before, discoloration of the stonework had led Mérimée to suspect that the carvings were impregnated with oil, making him touch some of the smaller columns more than once to convince himself that they were not made of bronze. He had no difficulty discerning that the slender column in the center of the doorway was fashioned of granite and antique in origin, although he didn't indicate how he came to his conclusion. Had he noticed the extra element inserted above the base to extend the column's height, or had the dinginess of the setting obscured the eye-level repair? The presence of the stone insert confirms his observation that the column is residue from another site; retrofitting

had been necessary when it was put in place on the threshold of the church.

The portal's scrubbing in the 1990s revealed that the small columns are also carved out of hard gray stone. Like the taller, central one, they were made for another structure and reutilized, creating a pronounced contrast with the sparkling whiteness of the adjacent marble reliefs. Appropriation of pre-used material would have been necessary in the twelfth century because the quarries from which colored stone came lay largely in the eastern Mediterranean and had been closed after the fall of Rome, remaining shuttered during the centuries of incursions that followed. Medieval builders interested in polychromatic embellishment of their structures were forced to take material from places where it had previously been employed. Such elements were easy to come by. Granite and marble from Turkish and Egyptian quarries had been lavishly employed in imperial construction throughout Rome's colonies.

Ancient theaters were one of the places where colorful columns had been used in abundance, framing niches on the wall behind the stage and embellishing the structure elsewhere as a way of demonstrating the wealth of the building's donors and sponsors. Surviving or reassembled structures in Spain, Turkey, Jordan, and Syria remind us of what has been lost in Provence, where the otherwise well-preserved theater in Orange lacks the multilevel columnar screen that originally stretched across the stage, providing openings for actors to enter and exit, with niches above for the display of sculptures. The design adhered, in most places and for the most part, to the model of the stage wall set out in Vitruvius's *De architectura*, a book written during Augustus's reign and dedicated to him.

The sparse remains of Arles's stage wall that are still in place

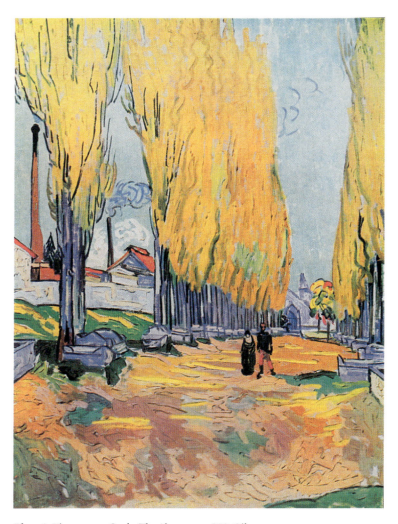

Plate 1. Vincent van Gogh, *The Alyscamps*, 1888. Oil on canvas, 93 × 72 cm (36^{39}/$_{64}$ × 28^{11}/$_{32}$ in.). Basil and Elise Goulandris Foundation, Athens.

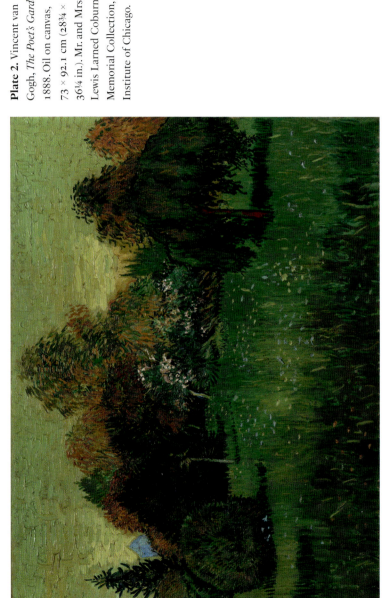

Plate 2. Vincent van Gogh, *The Poet's Garden*, 1888. Oil on canvas, 73 × 92.1 cm (28¾ × 36¼ in.). Mr. and Mrs. Lewis Larned Coburn Memorial Collection, Art Institute of Chicago.

Plate 3. Vincent van Gogh, *The Mulberry Tree*, 1889. Oil on canvas, 54 × 65 cm (21¼ × 25½ in.). Norton Simon Art Foundation, gift of Mr. Norton Simon.

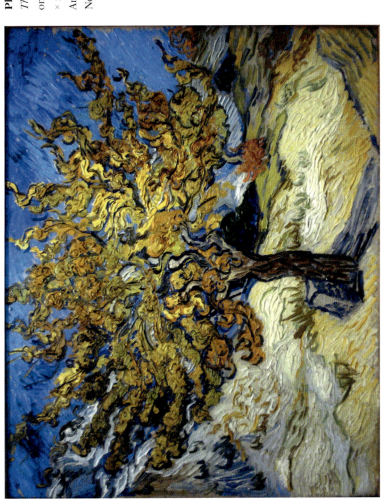

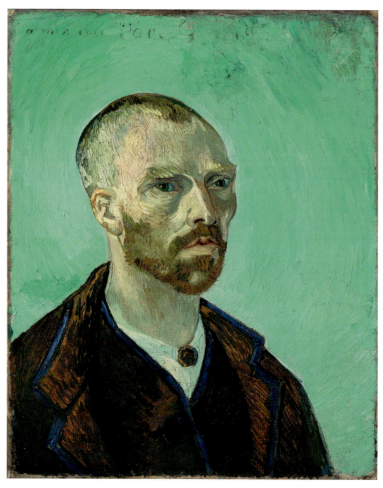

Plate 4. Vincent van Gogh, *Self-Portrait Dedicated to Paul Gauguin*, 1888. Oil on canvas, 61.5 × 50.3 cm (24³⁄₁₆ × 19¹³⁄₁₆ in.). Harvard Art Museums / Fogg Museum, bequest from the Collection of Maurice Wertheim, Class of 1906.

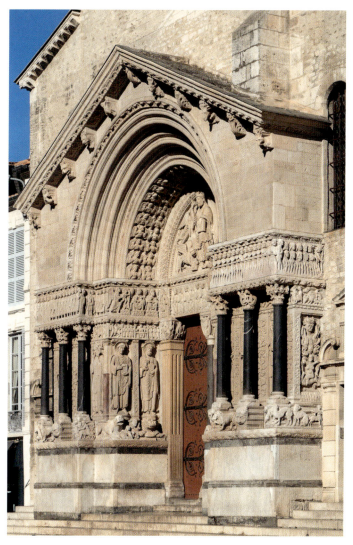

Plate 5. Saint-Trophime Church in Arles. Photo by Martin Kraft (CC BY-SA 3.0), creativecommons.org/licenses/by-sa/3.0/legalcode.

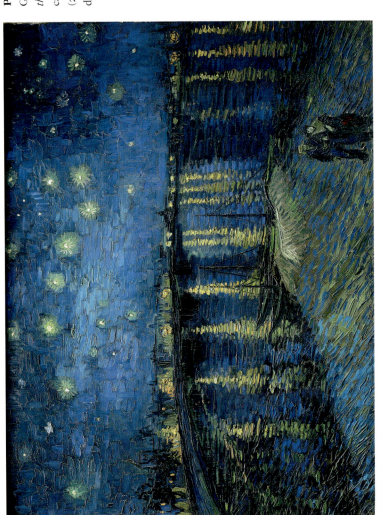

Plate 6. Vincent van Gogh, *Starry Night over the Rhône*, 1888. Oil on canvas, 72.5 × 92 cm (28½ × 36¼ in.). Musée d'Orsay, Paris.

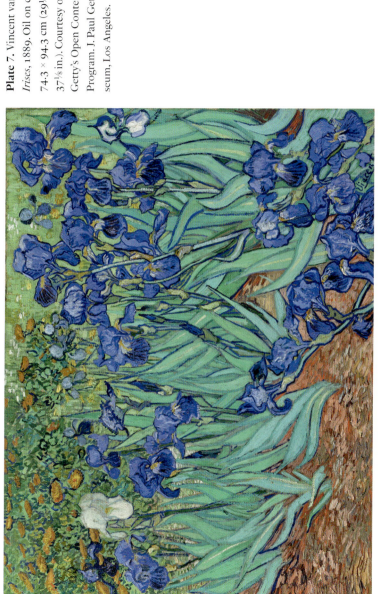

Plate 7. Vincent van Gogh, *Irises*, 1889. Oil on canvas, 74.3 × 94.3 cm (29¼ × 37⅛ in.). Courtesy of the Getty's Open Content Program. J. Paul Getty Museum, Los Angeles.

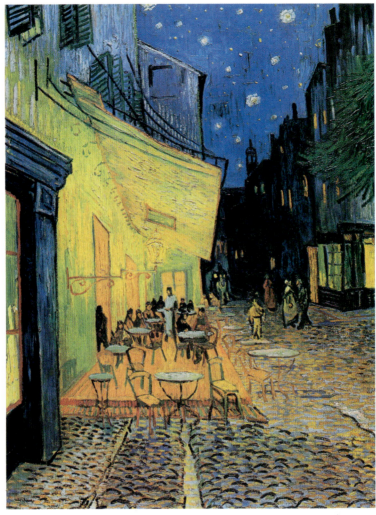

Plate 8. Vincent van Gogh, *Terrace of a Café at Night (Place du Forum)*, 1888. Oil on canvas, 80.7 × 65.3 cm (31$^{27/32}$ × 25$^{13/32}$ in.). Kröller-Müller Museum, Otterlo.

Figure 28. Remains of stage in Arles's theater. Photo by Kristen Bearse.

indicate that it followed that plan (figure 28). A pair of colorful marble columns tower above vestiges of other shafts, while remnants of the bases on which they stood indicate where the screen of columns forming the backdrop for performances was situated. The lofty columns were already legendary around 1200, when Gervase of Tilbury mentioned them. His comment that human

sacrifices had once taken place on their summit projected onto the shafts an association with the torture of Christians centuries before. Memory of one such martyrdom adhered to the colorful column on the other side of the Rhône to which Genesius was said to have been tied for his beheading. In the twelfth century, the column was part of a residence belonging to the Baux family, which held rights to the area from the late eleventh century on.

According to documents of the time, a family called the Carbonnières had its lodgings in a portion of the theater's remains. At a later but uncertain date, a church dedicated to Saint George occupied part of the theater's terrain. After its demolition in 1647, a convent of nuns took over the grounds and established a garden on the northern section of what had been the theater's stage. In 1651, workers digging a well there discovered, several feet below the ground, three or four substantial marble fragments belonging to a large statue of a standing female figure (figure 29). In 1684, the sculpture, called the Aphrodite or Venus of Arles, was sent to Paris as a gift for Louis XIV; the following year it traveled to the king's palace at Versailles, where François Girardon restored it before it was placed on display. During the Revolution, the statue was taken to the Louvre for storage along with other royal and religious treasures. This remnant of Arles's ancient theater has remained in Paris ever since, returning to Arles as a visiting dignitary in an exhibition in 2013.

Subsequent excavations in the ruins of the theater recovered additional statues and relief carvings: a trio of dancing women, parts of another Venus, and the torso of an over-life-size seated figure of Augustus. Mérimée's familiarity with them contributed to his remark that the theater had formerly been decorated with extraordinary magnificence. In his time, the sculptures were

Figure 29. Venus of Arles. First century BCE. Louvre Museum, Paris. Photo by Wikimedia Commons user Marie-Lan Nguyen (CC BY 2.5), https://creativecommons.org/licenses/by/2.5/legalcode.

stored in the church of Sainte-Anne on Arles's main square, alongside numerous sarcophagi. Vincent saw them there fifty years later, referring to a plaster cast of the Venus of Arles as an example of the elements of Greek influence that abounded in the region.

The installation of the carvings in the space of the new antiquities museum gives a sense of their original disposition. The colossal figure of Augustus is situated in the middle of the arrangement, confronting visitors as it would have faced spectators. The statues of Venus, formerly located in lateral niches, are positioned to either side. When in place, the sculptures communicated to the audience a dynastic connection between Augustus, Caesar's great-nephew, adopted son, and appointed heir (originally named Octavian), and Venus, from whom a deified Caesar was said to descend. The display of this illustrious lineage manifests the ancestral reverence at the heart of the imperial cult, in which the founder was believed to have had quasi-divine origins and each ruler was related to the one before, no matter the kinship leap involved in perpetuating that connection. Tiberius was Augustus's stepson (from his third wife); Caligula, who succeeded him, was Caesar's great-nephew and a great-grandson of Augustus; Claudius, Caligula's uncle, followed; Nero, who ended the Julio-Claudian dynasty, was Claudius's great-nephew (as well as stepson through his fourth wife, Caligula's sister, Agrippina).

We do not know how long the sculptural display in the theater kept alive the victorious general's memory in the city that helped him defeat Pompey, although the carvings likely stayed in place so long as the theater was in use. In the twelfth century, Caesar was recalled throughout Europe in numerous ways. *The Marvels of Rome*, a book describing the notable sites of that city, reported, on the basis of a misinterpreted inscription, that his

remains resided in a sarcophagus beneath an obelisk known as Saint Peter's Needle, near the apostle's church. The *Pilgrim's Guide* claimed that soldiers of one of the tribes Caesar sent to Spain to make war on settlers begot children with the widows of the men they murdered, a story purporting to identify the origins of the Basque people. The associations demonstrate widespread interest in antiquity, which historians view through different lenses, according to the nature of the material involved. Medieval citations of the work of Roman writers and the reuse of antique cameos and gems in works of art are regularly regarded as meaningful actions, even though they invariably fail to meet the level of understanding or insight subsequent centuries displayed. Architectural imitations and appropriations, in contrast, have tended to be perceived as acts of expediency, because of the ubiquity of Roman remains throughout much of Europe, and held in lower regard. Abbot Suger's remarks concerning ancient columns he sought to obtain from Rome for incorporation into Saint-Denis's choir in the years around 1140 are seen as an exception to regular practice, as was everything he did. His commentary assigned symbolic as well as structural significance to the shafts he hoped to procure for his church, providing them with a potency he would also attribute, at much greater length and with considerable rhetorical force, to the images of stained glass with which nearby chapels in his church were adorned.

Many of his contemporaries were similarly motivated. Although there is neither anecdotal nor documentary evidence of any transfer of material from the ruins of Arles's theater during the twelfth century, the alternately faceted and smooth colored stone shafts on Saint-Trophime's portal (along with those in the neighboring cloister) provide confirmation of such activity. Use of the earlier material for the new structures augmented Saint-

Trophime's auspiciousness in numerous ways, not least by recalling the passage in the liturgy celebrated on Bishop Hilarius's feast day. It mentioned a deacon's injury from pieces of stone falling from the theater during construction of the earlier church.

A local family had rights to what remained of the theater. Had they donated the columns to the church's construction, expecting that their deed would be rewarded? Whether or not they had that in mind, the decision to employ the shafts would have been the critical first step in the portal's conception, since their dimensions determined the proportions of the statues and reliefs around them. Such calculated inclusion of appropriated material would have been unthinkable in the early decades of the fifth century, when Arles's young cathedral was relocated from ground near the Roman wall to its present site close to the theater. In those years, churchmen decried associations between a place of Christian celebration and one of pagan performance; Saint Augustine had effectively condemned the theater as a site of immoral activity. But, as the threat of pagan display receded, attitudes changed. Texts written between the seventh and twelfth centuries, and well known in their time, trace stages in thinking by various theologians in which connections between the theater and the church gained acceptance.

The *Etymologies* of Isidore of Seville, a compilation of knowledge left unfinished in 636, was instrumental in this development. Comparisons made throughout the book's pages, between aspects of pagan antiquity and elements of Christian practice, rendered the former harmless by presenting them as inert examples. Although the things Isidore asserted were notoriously inconsistent, and many made no sense at all, they served as models for reflection and elaboration and were widely disseminated throughout Europe in the centuries after their author's death.

Writers in disparate monastic libraries consulted the *Etymologies*, employing its analogies to justify their own claims. Isidore's definition of the theater as an "enclosure for a stage" derived, he said, from a term for spectacle, because people standing within the theater observed plays. Its lower part, he continued, was built like a house, and held a platform (*pulpitus*) where actors and mimes performed. In another section of his work, Isidore explained that this platform was the place where "the reader or psalmist" could be seen and heard, aligning leaders of the church's service with their pagan predecessors. Around 1100, when Saint-Trophime was being planned, notions Isidore expressed began to be more directly connected to church ritual. An enigmatic writer, known as Honorius Augustodunensis, compared the priest's gestures during liturgical celebration to those used by an actor or tragedian telling a familiar story. By the third quarter of the century, such comparisons seem to have coalesced into practice. Directions in a vernacular play called *Le Mystère d'Adam* specifically identified the church as a venue for performance, with the stage positioned at the entry to the building instead of in the choir. Doors were to be used for the entrance of prophets as well as God, while the steps were reserved for lesser realms of activity; the audience was to be seated on the lowest level, directly in front of the door. There was no longer any moral impediment to the use of the church as a venue for performance, real or imagined.

The portal in Arles makes a similar point. The columns that were taken from the ruins of the theater and positioned to either side of the cathedral's central door create a miniaturized version of the setting from which they came, identifying the entry to Saint-Trophime as a stage for the reenactment of Christian history. Visitors, caught in the narrow passage between buildings

framing the road in front of the portal, could have imagined themselves standing in a theatrical enclosure, as Isidore had described it, with the sculptures as the actors emerging from the entry, just as the directions for the mystery play suggested.

In the late nineteenth century, Arles's residents used the theater's ruins during daylight to get from one part of the city to another, activity Henry James perceived as enabling the past to touch the present, and letting the place "live a little." At some point, the paving of a narrow street severed the topographical relationship between the remains of the theater and land to the west on which the church and cloister stand. The gate now enclosing the ruins isolates and identifies the site as a historic monument, obscuring the spatial and material history it once shared with the nearby church and preventing visitors from imagining the connections between them that medieval viewers could have easily grasped.

SEEING STORIES

Despite the destruction occurring all around the cathedral, the portal's carvings stayed intact, the figures not losing "a nose or a finger," a feat Henry James called "one good mark for the French Revolution" (figures 30 and 31). Those on the inner corners represent the holy men to whom the church was serially dedicated, Stephen on the right and Trophimus on the left. They are accompanied by eight apostles, shown in pairs on the outer portions of the portal's front face and on both sides of the entry. Together the figures and the accompanying friezes recount a story of the Church's origins and mission that would have been accessible to local viewers as well as visitors coming from afar, but has become difficult for current visitors to understand, given the density of its scriptural, theological, and historical references.

Trophimus, the evangelizer of Provence and purported first bishop of Arles during a period of Roman rule, appears in episcopal regalia as an icon of strength and sobriety, agent of the area's

{90} SEEING STORIES

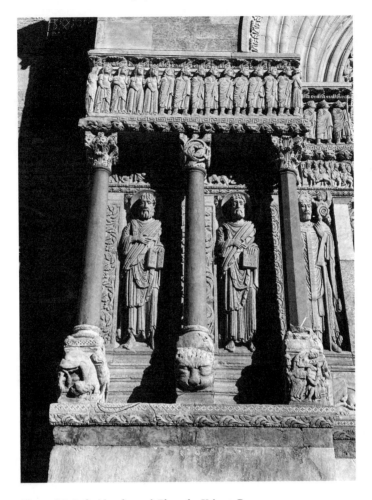

Figure 30. Left side of portal. Photo by Kristen Bearse.

earliest conversions. The staff he holds, and the miter raised over his head, define his stature and identify his earthly mission: advancement of the cause of Christianity in a still-Roman world. His attributes announced the elevated status of the building within which his remains were preserved. In the early fifth cen-

SEEING STORIES {91}

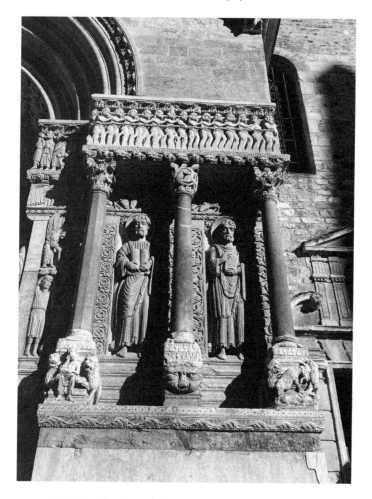

Figure 31. Right side of portal. Photo by Kristen Bearse.

tury, Arles had been made the seat of a bishop, retaining that distinction until early in the nineteenth century. Figures of John and Peter stand next to Trophimus on the sidewall of the entry; all are carved in marble, the shared material connecting Arles's first bishop with Jesus's earliest followers (figure 32).

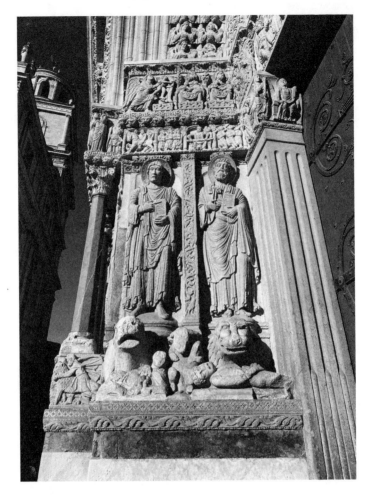

Figure 32. Left side of entryway. Photo by Kristen Bearse.

A pilaster fragment of purple stone, salvaged from antique remains and extended to fit its new situation, defines the corner between them as an axis around which the figures pivot. A similar element on the other angle of the portal connects the apostles Andrew and Paul to Stephen, the church's first titu-

lar saint and Christianity's first martyr, who is shown dressed as a deacon and kneeling in a scene depicting his death. Stephen belonged to the small group of disciples designated by the apostles shortly after Jesus's resurrection to minister to the growing community of believers. According to Acts 7, his passionate preaching led to an accusation of blasphemy, and he was cast out of the Temple and stoned. Stephen's relics migrated west early in the fifth century, when various new foundations throughout the Mediterranean were named in his honor. Depictions of his death, wherever they appeared, acknowledged public dissension and sanctioned personal sacrifice in support of one's beliefs. In the twelfth century, disagreements within and among civic, seigneurial, and religious communities played a critical role in local Provençal life, a point that the relief of Stephen echoed in this location.

The figures to the right of Stephen hold books inscribed with the names James and Philip. Even for those unable to read, the lettering would have been understood as a sign of the figures' authority, something communicated as well by their upright postures and sober demeanors. The names identify them not only as apostles but also as individuals tasked with the formation of the church in the years following Jesus's death. In Acts 6:5, someone named Philip is appointed deacon of the church along with Stephen (and five others); in Acts 15:13–21, an individual identified as James speaks at a council in Jerusalem to resolve a debate involving the newly converted. Early writers often confused or conflated the identities of these individuals with the apostles Philip and James the Less; a similar elision would have been inescapable in the twelfth century, in the administrative center of the bustling city.

Arles, at the time, was governed by twelve of the "most suit-

able" men. The document establishing their selection stipulated that they should represent distinct parts of the city and include four knights and four burghers, two men from the market, and two from the northern part of the city that was known as the new bourg. This diverse group, chosen by the city's electors in consultation with the bishop, was invested with power to judge and to execute judgments and to settle internal disputes. Other statutes in the document, attributed to the reign of Archbishop Raimond de Montredon (1142–60), addressed aspects of economic life in the city, including the regulation of weights, measures, and fairs. For residents of Arles and those who passed through it, the figures on the portal evoked representatives of the early church as well as those of the current, commercially engaged community.

The narrow frieze running across the portal, behind the columns' capitals and above the figures' heads, depicts the familiar story of Jesus's infancy. Because of the slightness of the recess in which it is situated, episodes appear to be connected to the standing figures, making the oversize sheep between Philip and James appear to be props in the saints' stories instead of participants in one involving shepherds (Luke 2:8–14). The essential figures in that Gospel event, an angel and two herders, are situated behind the central capital and at the ends of the frieze, positions in which they are rendered nearly invisible. As initially conceived, they would have been easier to see. The capitals in front of them are carved in the round, indicating that they were planned for a less engaged situation, one that would have afforded greater depth and visibility to the imagery unfolding on the wall behind. Even then, however, the shepherds would have been overwhelmed by the size of the sheep.

The imbalance in stature suggests an independent role for

the animals, in a story of their own. Abundant grassland in the Rhône delta has long been responsible for a sizable portion of Arles's prosperity. As pastureland for grazing sheep and other animals, it brought clerical and civic powers together in the Middle Ages. Whoever served as bishop automatically became the overseer of land the church owned, collecting rent from those using it for grazing. The raising of lamb and the sale of wool provided a substantial portion of the wealth of local families. An image of long-bodied sheep on the seal of the powerful Porcelet family recalls the animals shown in the frieze. Residents of the region could hardly have avoided noticing such connections between church authority and local activity as they passed the portal on their rounds through the city.

Other events in the narrow frieze's story of Jesus's infancy are conflated with the lives of the apostle figures on the left side of the portal. The imminent beheading of a child in the scene of the Massacre of the Innocents (Matthew 2:16) above the figure next to Trophimus identifies it as James the Great, the apostle who suffered a similar fate at the hands of Herod Antipas (Acts 12:2). His remains miraculously made their way to northwest Spain, the goal of the journey that many of the pilgrims passing through Arles were pursuing; the road in front of the portal led to the bridge across the Rhône where travelers accessed the route toward Iberia. On the concluding portion of the frieze, above Bartholomew's head, the direction taken by the holy family on their flight into Egypt (Matthew 2:13–15) parallels pilgrims' movement toward James's tomb. The scene invokes this apostle's travels to distant places, during which, according to various legends, he occasionally masqueraded as a pilgrim.

Within the entry, reliefs above the apostles' heads recount the magi's journey to the newborn Jesus and their encounter

with Herod (Matthew 2:1–12). The birth of the baby who would become king of the Jews had been prophesied by both Isaiah (7:14) and Micah (5:2–4). In acknowledgment of the prophecy, the last of the kings on the right side elevates his glance and extends his hand upward, pointing toward the depiction of heaven's gate in the register above (figure 33). Meanwhile, the first king's presentation of an offering at the threshold to the church provides visitors with a model for their own behavior. The magi then move across the portal, continuing a trip that appears to have originated south of the city.

In medieval times, any pilgrims coming to Arles from that direction and failing to stop at the cemetery to say prayers for the dead would have been visually admonished to return to the burial ground when they caught sight of the figures of the saved and the damned moving in the opposite direction on the portal's large frieze. These processions evoke Jesus's parable of the shepherd's separation of his flock into sheep and goats, with one group meriting eternal life in a kingdom established at the Creation and the other condemned to everlasting punishment in the devil's fire (Matthew 25:31–46, especially verses 34, 41, and 46). In the early Church, the event was depicted with animals as stand-ins for the saved and the damned. In subsequent centuries, a more subtle scenario developed, as theologians debated whether certain individuals might be spared the prospect of unending punishment. In the eighth century, the Venerable Bede introduced the notion of a place where the souls of the departed could gain forgiveness for sins committed during their lifetimes. Church scholars embraced his idea, developing the notion of purgatory as the place for those meriting partial redemption; not everyone had access to it, since some transgressions were deemed too egregious to be offset. Expiation of lesser sins was

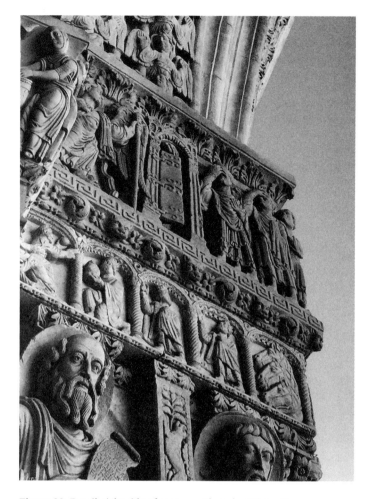

Figure 33. Detail, right side of entryway. Photo by Kristen Bearse.

made possible by prayers said by the living, whose offerings had the capacity to reduce lengthy punishments for those in whose names the prayers were pronounced. This enabled them to enter a place of refreshment while waiting for the trumpet's call.

"Purgatory made sure that the dead would be remembered,"

Peter Brown observed, adding that "it depended on the prayers of human intercessors—on human groupings of relatives, friends, fellow monks, and clergymen." The *Pilgrim's Guide* endorsed this activity, advising its reader to go to the Alyscamps, a short distance from the cathedral, to offer "prayers, psalms, and alms" on behalf of those whose bodies were interred in the cemetery's coffins. The comportment of figures in Arles's prominent frieze points to that place, a short walk from the church through a gate in the wall that had been built around the southern edge of a shrunken city in the early Middle Ages. Those following the sculptures' directive participated in the Church's plan for the salvation of Christian souls and could expect to be rewarded in the afterlife for what they were doing in this one, on behalf of others.

The processions of the blessed and the damned reinforce the outer edges of the portal, placing the figures, structurally and spatially speaking, in an in-between space—a place of delay—and aligning them with then current thinking about the situation of souls between death and the moment of eternal judgment. The cortege of the blessed ends mid-portal, confronted by images of bearded patriarchal figures coddling doll-like forms on the left side of the door. The carvings represent Abraham's bosom, where the poor man Lazarus was carried by angels after his demise (Luke 16:22). By the twelfth century, this was the name given to the place where the redeemed would await their final call. Immediately below, smaller figures push aside the lids of coffins with clasped hands. Circular openings in the sides of the sarcophagi imitate the "portholes" on the tomb in Jerusalem revered by pilgrims as the one in which Jesus's body had briefly lain. The holes allowed pilgrims visiting the Holy Sepulcher to reach in and touch the bare interior, confirming, in an unmediated way, Jesus's bodily resurrection and, with it, the prospect of

their own salvation. A miniature sarcophagus on one of the lintels at the church of Saint-Gilles-du-Gard, a few miles away from Arles, similarly allowed visitors to that church to "see" Christian truths for themselves. In a depiction of the three Marys asking an angel about the whereabouts of Jesus's body, fluttering ends of the shroud in which Jesus was wrapped for burial draw attention to openings into an empty coffin.

The cortege of the blessed begins around the northern corner of the portal, next to a depiction of Adam and Eve's Temptation. In contrast to the account provided in Genesis 3:1–7, where Eve is the transgressor, the pair is shown partnering in disobedience, one about to pluck a fruit from the tree while the other appears ready to receive one from the snake (figure 34). According to the parable in Matthew 25:34, immediately after separating the sheep from the goats, Jesus told his listeners that those on the King's right would dwell in a special place established at the same moment as the Creation. The scene in the Garden of Eden thus provided assurance to visitors arriving at the portal from the northern part of the city of the existence of a place where the redeemed dwelled while awaiting the final call. On the other side of the doorway, the unredeemable, those whose sins have not been forgiven, are chained to one another, their feet covered in flames. Though they face in the direction of the cemetery, they will never arrive there. Around the corner, in a position corresponding to the scene in the Garden, disembodied male and female heads hover in a boat adrift on a river of fire, guarded by a tall, demonic figure holding a pitchfork (figure 35). The situation of these individuals had also been foretold when Jesus announced that those on the left hand would be condemned to eternal fire prepared for the devil and his angels.

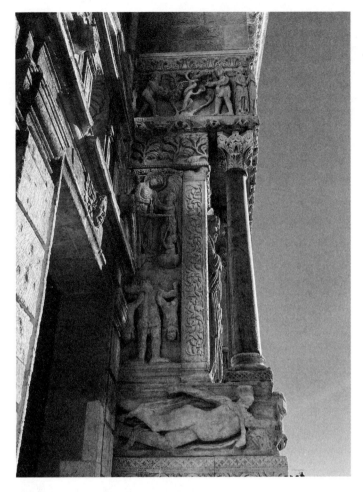

Figure 34. North side of portal. Photo by Kristen Bearse.

The imagined road the magi follow in their flight from Herod on the smaller frieze parallels the ancient one devotional travelers took to cross the Rhône, the direction in which the *Pilgrim's Guide* urges the reader to proceed. This path passed the northern quarter of the city, where the Templars had established

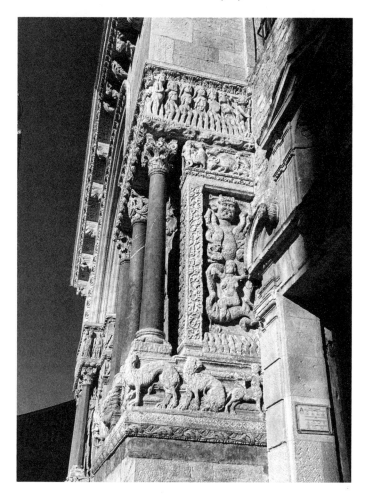

Figure 35. South side of portal. Photo by Kristen Bearse.

themselves in the 1140s, and continued toward the suburb of Trinquetaille, where Genesius's column stood; Hospitallers had acquired the nearby church of Saint-Thomas in 1117–18. Both military orders, which had been founded in the Holy Land during the period of the First Crusade, provided charitable and

religious services to pilgrims and commercial travelers wherever they established their houses. These activities included burials, diverting revenue from local churches and producing conflicts over the loss of fees. In Arles's urban landscape, the portal's noteworthy depiction of figures advancing toward the Alyscamps, over which the city's bishop held sway, countered the thrust of the diminutive magi's movements in the direction of the other establishments.

CROSSROADS OF THE MEDITERRANEAN

Whether pilgrims from Italy on the way to James's tomb in Compostela traversed ancient land routes or sailed out of Genoa's port on commercial boats, they were reminded of what they left behind by what they saw in Arles. The austere scheme of white marble plaques separated by strips of dark stone on the lower portion of the portal resembles the banded treatment of the cathedrals in Genoa and Pisa. In 1155, while the portal was under construction, Arles signed a commercial agreement with Genoa assuring the seaport an inland point of distribution for its cargoes. The decoration at the entry to Arles's cathedral publicly proclaimed these ties, affirming the city's role as a commercial center, for which it had been prized since ancient times.

One of the things for which marble is treasured is its hardness. In Roman times, the stone's whiteness along with its durability made it meaningful for use in the coffins of particularly notable individuals. Initially, this meant aristocrats; in the early

years of Christianity, the bodies of holy men began to be afforded the same privilege. The placement of Hilarius's remains in an appropriated sarcophagus in the Alyscamps announced the bishop's elevated moral and social status to those visiting his tomb. In subsequent centuries, the use of marble continued to be a mark of prestige. According to an account of the recovery of Saint James the Great's remains in the early ninth century, his bones were found in a marble vessel by a monk named Pelayo in a place littered with other marble tombs; a mysterious light had pointed out the spot. The identification of the find site gave the place its name, Compostela. Some scholars claim that the words described a starry field (*campus stellae*), while others suggest that they signaled a burial ground (*compositus*); both hint at the presence of sparkling stone sarcophagi. Excavations within the church built above what were believed to be James's relics have revealed the existence of an early martyr's burial surrounded by other interments, archeological confirmation that the site was a cemetery in Roman and early Visigothic times.

At Saint-Trophime, the marble plaques closest to the entry likely came from sarcophagi. In the fourth and fifth centuries, Arles had been a center for their manufacture. In the twelfth century, the Alyscamps still possessed innumerable marble tombs, carved in distinctive styles and inscribed in Latin. The *Pilgrim's Guide*, the source of this information, noted that no other place was like it: the farther you looked, the more tombs you would see. Perhaps in tribute to the splendor of the early carvings, the sculptors reworking the salvaged stones drew inspiration from them, in the way that stonemasons constructing the portal had done when appropriating material from the theater. The crisply carved arcading beneath which the magi enact their journey on the sides of the entry imitates the architectural

framing on so-called "city gate" sarcophagi of the fourth century, several of which are on display in the museum of antiquities. Christ appears amid the apostles on the earlier work, reinforcing our sense that the magi, too, participate in an emblematic, not merely anecdotal, tale. Figures in the larger friezes on the front face of the portal evoke configurations on other sarcophagi in the museum. The relaxed postures and overlapping bodies of the blessed recall striding figures of Israelites and Christians on so-called "frieze" sarcophagi, while the sinuous postures of the sinners echo the undulating bands of strigils on another group of coffins. This design, which is based on the curved shape of the instrument used by athletes in ancient competitions to cleanse their skin after performances, introduces into the portal's frieze the idea of the physical contest or struggle in which souls were believed to be engaged.

An invisible, although essential, element in the portal's construction is mortar. Its prime ingredient, lime, is extracted from calcium-rich stones such as marble and limestone through incineration. Places that lack adequate raw material need to import it for their building projects. A passage in chapter 3 of the *Pilgrim's Guide* notes that those passing through Galicia on the way to James's tomb were given stones to carry to another location (ostensibly one with an oven) for conversion into lime. From there, the material was taken to Compostela for use in the basilica being built over the apostle's shrine. Discovery of a kiln in the basement of a building immediately across from the church of Saint-Sernin in Toulouse attests to the existence of a facility for extracting lime close by. The oven's location, in what had been an abandoned cemetery, provided material for its firing; fragments of marble sarcophagi and portions of column shafts, not yet incinerated, remained inside when the kiln was uncovered.

Arles's surfeit of requisite ingredients for producing mortar, particularly on the grounds of the ancient theater, makes me wonder whether the Carbonnières, whose name comes from the word for charcoal, might have had an oven for the extraction of lime on a portion of their property there. Whether or not this was so, the transformation of discarded material from pagan structures and tombs into an essential ingredient for the construction of churches evokes the sorts of metaphors, verbal and visual, that assisted medieval viewers and listeners in comprehending Christian truths; they continue to do so for us.

Materials brought associations with them in the same way that images and stories did. The fine-grain limestone in which the apostle figures on the outer portions of the portal's front face are carved came from quarries on the other side of the river, at Bois des Lens, a few miles northwest of Nîmes. This material, notable for its warm color, had been employed in Roman times for the decoration of local monuments and for sarcophagi. The torso of the large figure of Augustus that filled the central niche in the stage wall of Arles's theater was made of the golden stone. In the twelfth century, it was the material of choice for decorative elements on churches being rebuilt at many places in the region. In addition to Saint-Trophime, stone from Lens was used for carvings at Saint-Gilles-du-Gard, Beaucaire, and Nîmes. Since there is no evidence of extraction from the quarries during the Middle Ages, it is thought that the blocks were cut in Roman times, when activity at the quarries is not in doubt. After lying dormant for centuries, the stones were shipped to destinations along the Rhône and its tributaries, as such stones had been centuries before.

The first carvings travelers saw as they approached Saint-Trophime along the main road through Arles were those on the

narrow sides of the portal. These hint at themes of judgment and punishment without referencing scriptural sources for authority. On the north side, two formally related but thematically oppositional scenes are vertically aligned (see figure 34). At the top, a large richly clad winged figure suspends a scale from the fingers of one hand while holding the arm of a smaller, unclothed figure with the other and peering into its eyes. One of the two baskets hanging from the crosspiece of the swordlike scale contains the half-length form of a praying figure; the other, now obscured by the frame of an adjacent doorway, hangs askew, its tilt signaling the insufficiency of its (masklike) contents.

Immediately below this representation of the weighing of souls is a smaller configuration of figures; it recasts the image above by condensing its elements into the form of an anthropomorphic balance. The extended arms of the central naked figure create the crosspiece of this instrument, from which two undressed figures dangle upside down. The grouping replicates, with remarkable exactness, an early Greek image of Herakles carrying off the Kerkopes, an incident in the life of the mythological figure in which he punishes two tricksters for stealing his weapons. The carving's resemblance to a depiction of the event on a metope from Hera's temple in Paestum, and another at Selinunte (Selinus), in Sicily, both made more than a millennium and a half earlier, suggests that an object on which the vignette was painted or incised provided the inspiration for the image's depiction. The source could have been a vase, brought to the south of France by the region's early Greek settlers or imported afterward by Romans who made their predecessors' cultural and artistic accomplishments their own. Fragments of black-figured pottery in the nearby museum attest to the existence of such material in the region.

The rendering of the figure in the relief on the portal is distinctly unheroic. With its conical hat, naked buttocks, and grotesque feet (invisible to a viewer standing below), it presents viewers with an image of an antihero, someone whose story is in some way compromised or stained, making him susceptible to mockery. According to legend, the series of labors for which Herakles came to be known were performed as remediation for the murder of his wife and children in a fit of anger. Memories of this dark deed, as well as depictions of it, were never as popular as representations of him dispatching a series of formidable animal opponents through cunning as well as bravery. The most celebrated of these heroic deeds involved the conquest of the Nemean lion, in which he used the beast's own claws to strip away its skin when he realized that the animal was impervious to weapons. The hide became Herakles's signature attribute; countless images from antiquity through the Middle Ages, when the demigod is identified as Hercules, show it draped around the shoulders of his muscular body.

Beneath the figure of Herakles with the Kerkopes is a carving of a seminude figure wrestling with an animal that appears to be a lion but is too abraded now for one to be sure. At first this figure also seems to be Herakles, the animal skin around its shoulders implying the identification. Yet its horizontal posture suggests a fallen warrior rather than a victorious one. Closer inspection discloses another pictorial anomaly: cloven hooves instead of the expected leonine ones dangle from the hide between the figure's legs. Hooves characterize deer, boars, horses, bulls, and cattle—even-toed ungulates, beasts Herakles encountered without killing. In twelfth-century Arles, they brought prosperity to Arles's residents. In the newer section of the city north of the cathedral, butchers sold the meat and skins of cattle that

had spent their lives grazing on the meadows and marshlands outside the city.

In earlier times, animal skins played a role in local ceremonial practices. According to Caesarius, celebrations at the beginning of the month of January included festivities in which participants sported stag antlers and clothed themselves with hides. These were Celtic customs that Romans adopted in the regions they conquered. Memory of them lingers in *The Song of Roland*, where the bodies of the heroes are wrapped in shrouds of deerskin before being taken to the church of Saint-Romain at Blaye, near where they had been killed in combat, and placed in white (marble) sarcophagi. *The Chronicle of Pseudo-Turpin*, a contemporary prose retelling of the Roland story, in which the battle against Muslim soldiers is presented as authoritative history, renders the episode differently. Turpin, the legendary archbishop who dies alongside Roland in the *Song*, survives in the *Chronicle*, journeying with Charlemagne through Gascony and Toulouse with the remains of the fallen for burial in the Alyscamps. This alternate account of the siege in the Pyrenees and its aftermath forms part of the collection of texts to which the oldest known version of the *Pilgrim's Guide* belongs. Although travelers arriving in Arles may not have been thinking about or even known any of this as they approached the church, many would have been familiar with one or another account of Roland's story, hearing it recited at stops on the way and associating what they remembered with things they saw.

Performers of songs and stories provided travelers with a preview of subjects they were likely to encounter in imagery on the churches they visited. An animal skin and a scale, prominent features in different reliefs on the portal's north face, are critical components of a Latin fable found in an eleventh-century com-

pilation. The tale, called "Unibos," involves a cunning peasant's repeated sale of the hide of his dead ox as a magical, moneymaking asset. At the markets at which he displays the pelt, a device ordinarily employed for weighing wheat is used to calculate the value of the coins handed over by those falling for his scheme. The story has provided the basis for countless trickster tales throughout the centuries and is known in various languages. The Latin version, with its swindler and his scale, coincides with aspects of Saint-Trophime's Heraklean imagery without belonging to the Greco-Roman hero's story. Whoever introduced the image of Herakles and the Kerkopes into the design of the portal's north side likely recognized its resemblance to the form of a scale, a utilitarian object for weighing commodities (as in the fable) as well as a symbolic one for measuring virtue (as in the judgment of souls).

The location of the semidraped figure on the lowest register of the portal aligns it with two biblical figures whose power derived from their demonstration of faith in the face of treacherous behavior. A representation of Samson with his head being shorn while Delilah restrains him appears at the base of the column framing the figure of Trophimus. Delilah's initial attempts to trick Samson into revealing the secret of his strength so that the Philistines could overpower him failed. Although she succeeded on her fourth try, he was able to bring about his enemies' deaths, albeit at the price of his own (Judges 16: 4–30). Across the entry, a depiction of Daniel amid the lions is situated next to the scene of Stephen's stoning. Daniel was banished to the cave of the lions through the duplicity of provincial governors jealous of his growing powers. They persuaded King Darius to ban prayers in the name of anyone other than himself, knowing that this would compromise Daniel, whose faith prohib-

ited him from bowing before an earthly ruler. Daniel's refusal to comply with the order condemned him to the lions' den (Daniel 6: 4–22). His commitment to his faith, which connects him to Stephen, calmed the animals into the benign postures in which they are shown.

Allusions to deceptive or deviant behavior on the lowest level of the cathedral's entry warned thieves and charlatans of the risk of exposure while reassuring those of good faith of the Church's protection. On the narrow southern face of the portal, a grisly carving confronts visitors with a comparable message (see figure 35). The head of a naked woman sitting on a snakelike dragon obscures the genitalia of a monstrous figure immediately above. He is shown holding in his arms a pair of overturned figures, recalling, or foreshadowing, the figure of Herakles with the Kerkopes on the other side of the portal. The configuration of unseemly shapes alludes to sins of the flesh, real as well as imagined, a recurrent subject in Provençal poetry and in the *Pilgrim's Guide*, where lascivious behavior along the way to Compostela is described without always being vigorously condemned. Frank anatomical depictions and scenes of erotic activity on the periphery of portals and under the rooflines of buildings at churches along the roads pilgrims traveled attracted attention to such conduct, eliciting engagement with it while cautioning onlookers about its dangers and consequences.

Prostitution presented communities with a particular conundrum. According to documents of the time, it was tolerated in many places because of its economic implications. In some settings, marriage to a prostitute for the purpose of her reformation counted toward remission of one's sins. Civic records show that Arles started to regulate prostitution early in the thirteenth century, not by condemning the activity, but by

requiring women to seek their assignations away from the city's center and outside its walls. The portal relief, put in place a few decades earlier, communicated the same message: it scared prostitutes away from the portal's perimeter while alerting them to the punishment they were destined to receive. The Bishop of Seville, living at a time when theaters were still being maligned for the dangerous activities that occurred within them, had noted the propensity of immoral women to linger outside such venues, soliciting customers. The sculpture's location, adjacent to a stagelike arrangement of columns, summons up Isidore's remark in the *Etymologies*, of which a few of Arles's churchmen, at the least, would likely have been aware.

The portal's carvings were assembled in the way sermons were, with material based on passages from scripture and Christian commentary intermingled with anecdotal, folkloric, and mundane material. While much of what was visualized reformulated what could be found in texts of the time, other elements engaged things that were primarily spoken about. These escaped the sort of documentation on which we are accustomed to rely, making it impossible to identify, in any conclusive manner, the range of references the portal's imagery evokes. It presented passersby most conspicuously with figures, subjects, and materials affirming Arles's claim to be an ancient center of Christianity in which one's prospect for the afterlife was inextricably tied to pious deeds and virtuous behavior in this life and in this place. At the same time, its imagery reinforced the trajectory of the worldly journey its viewers were making as they passed through the city on their way to other shrines. The distance they could cover in a day depended on the terrain, the weather, and their mode of travel; provisions and accommodation for themselves, their companions, and their horses needed to be located.

The *Pilgrim's Guide* addressed these concerns. Chapter 2 enumerates distances from one place to another along Spanish roads to indicate how long the trip might take. The estimates, however, are no more plausible than the claim made in the *Etymologies* that the length of the *stade*, a Greek unit of measurement, was determined by how much ground Hercules could cover in one breath. The legendary hero was said to have traveled through the region ages before, driving the cattle he had taken from the multiheaded giant Geryon in the southernmost corner of Iberia to Italy. For anyone traveling these roads in the twelfth century, the depiction of him on the corner of the portal in Arles summoned up varied associations with the risks, realities, and dreamed-of rewards of the trip that lay ahead.

PILGRIMAGE FACTS AND FICTIONS

According to the *Pilgrim's Guide*, four roads, each of which began in a part of what is now known as France, led toward Compostela, converging on the Spanish side of the Pyrenees. The route starting in Arles is the first one described; the second stop along it is Saint-Gilles-du-Gard, eleven miles away. This Benedictine abbey had been established at an uncertain date over the tomb of a local hermit. The account lavishes praise on the saint's holiness, likening him to "a brilliant star illuminating the people of Provence with its rays," and claiming that no other saint (after the prophets and apostles) was "more worthy, none more holy, more glorious, more prompt in giving help." His many miracles included the taming of a doe that then became his companion; restoration of a sick man's health when he put on the saint's tunic; and forgiveness of an unspecified sin of Charlemagne, the last two testifying to Gilles's posthumous power. The saint's remains, so potent that they were said to be immovable, were

enshrined in a large golden casket behind the church's altar. A detailed description of its ornamentation allows the reader to visualize its multiple registers of figural and architectural imagery and marvel at its splendor. The adornment on the ridge of its lid alone included thirteen crystals in the shape of apples, pomegranates, a checkerboard pattern, and a fish.

An inscription on one side of the reliquary cursed anyone who would damage it; the anathema was ineffectual. Although the casket's size and weight made it too big to steal, it was easily disassembled and destroyed. Smaller reliquaries, with similar but reduced decoration, survived the Middle Ages. Those not in museum collections are paraded through their parishes on feast days, as they were in the Middle Ages, and then returned to their sanctuaries in a ceremony commemorating the arrival of the saint's remains at his or her home. On these occasions, recitation of the story of the saint's (invariably) harrowing life is experienced as an enactment of his (or her) earthly journey, animating the celebration and making it memorable. A saint's presence promised steadfast protection to those within its purview so long as proper attention was paid. In instances where the holy remains were insufficiently attended to, relics accepted invitations to take up residence elsewhere. That is how thefts of sacred objects were explained, as Patrick Geary has shown.

The place the *Pilgrim's Guide* directed the pilgrim to visit next was where the remains of the blessed confessor William could be found, "in the valley of Gellone," some sixty miles away. The text doesn't define the distance, nor does it note that the way to Saint William's tomb involved passing through rocky wilderness, fording streams, and scaling gorges. Instead, it offers a brief biography of the saint, a historic figure of the House of Toulouse who had fought on behalf of Charlemagne before

retreating to the mountains beyond Montpellier and establishing a monastery, where he died in 812. In the early years of the twelfth century, an account of his life was composed by monks tending his tomb, and the abbey he founded at Gellone was rebuilt and renamed Saint-Guilhem-le-Désert in his honor. In the same years, troubadours began singing of his deeds. A cycle of poems reports how he, along with other family members, led efforts against Muslim forces in the territory around Nîmes during Charlemagne's reign. A painted wooden box, made in the early thirteenth century and now in the Met Cloisters museum in New York, is decorated with lively scenes of William's efforts to recapture Orange. Its modest material and plainly rendered imagery indicates the story's popularity during the years in which the counts of Toulouse and the counts of Barcelona, major landholders in southern Gaul and northeastern Iberia, were at odds over control of nearby territories. How hazardous their dispute made passage through the region cannot be fully known, given the sparse documentation of the period and the partisan nature of the visual as well as textual testimony.

A shrine for three little-known saints, Tiberius, Modestus, and Florentia, follows on the itinerary of relics the pilgrim should revere. According to the *Guide*, the martyrs, who were tortured during one of Diocletian's persecutions, reposed "by the Hérault River in a most beautiful tomb." Other sources suggest that their burial was at Saint-Thibéry, which lies along the coast close to Agde. To get there from Saint-Guilhem, pilgrims would have had to traverse rough terrain before reconnecting with the remains of the roads Romans had built; Agde was near the juncture of the Vias Domitia and Aquitania. In the center of Narbonne, paving stones of one of the ancient roads are framed, like relics, in an open square. Paulus, one of Trophimus's com-

panions, had been sent to the city in the third century; a church built in his honor and refurbished in the twelfth century stood on an ancient cemetery in another part of town. The *Guide* does not mention Narbonne, even though the city was, at the time, a key place over which neighboring counts were competing for the hand of its heiress, Viscountess Ermengard. Marriage to her would bring control of Narbonne and, with it, power over the surrounding territory.

Instead, the pilgrim is directed back to the route that begins in Arles. From there he advances to "the beautiful location close to the city of Toulouse" where Saturninus, another one of Trophimus's companions, was buried. Nothing is said, however, of the saint's memorial in the "immense basilica constructed by the faithful" in the late eleventh century. The marble plaques now in the walls of the church's ambulatory, believed to have originally decorated that structure, are not described. In their place, the reader is provided with an account of Saturninus's martyrdom, how he was "seized by pagans . . . attached to savage and untamed bulls, and had his head crushed, his brains scattered, and his entire body torn to pieces."

After Toulouse, churches along the three other roads leading to Compostela are mentioned; few appear to have been seen firsthand but each is reported to be remarkable. Sainte-Foy, the only sanctuary mentioned on the route beginning in Le Puy, has "in front of its portals . . . an excellent stream more marvelous than can be told." The hilltop abbey church at Vézelay, marking the start of the road running through the Limousin, houses the most-precious remains of Mary Magdalene, which "rest in a revered tomb." They had been brought there by a monk named Badilo in a legendary theft from Aix. The church at Saint-Léonard-de-Noblat houses "thousands upon thousands of iron

fetters, more barbarous than can be told ... bearing witness to [Saint Leonard's] great miracles." Included among the latter is his exceptional ability to deliver captives from prison, "even those enchained in penitentiaries beyond the seas." This claim, together with a subsequent comparison of the round tomb of Saint Fronto at Périgueux with the Holy Sepulcher, suggests that the Crusades were on the mind of the anonymous writer of the *Guide* as he composed his itinerary of places the pilgrim should visit.

Accounts of journeys to the Holy Land proliferated in Europe in the aftermath of the Frankish capture of Jerusalem in 1099. The author of the *Pilgrim's Guide* was undoubtedly familiar with one or another of them, through inspection of manuscripts in a library or via firsthand reports, utilizing them as a model for his own narration of pilgrimage in Gaul even though (or precisely because) circumstances there were so different. Those who traveled along the eastern shores of the Mediterranean traversed a topography made familiar by events described in the Old Testament and spiritualized by Jesus's movements. Stories that returning Crusaders recounted used vivid language to make these places come alive, even though many had already been inscribed in popular imagination. In contrast, the solitary backstory for the routes to Compostela involved Roland's encounter with Muslim forces in the western Pyrenees. The most celebrated account of that event emerged in the later decades of the eleventh century, in varied oral versions that were then condensed into the form that has come down to us. By the time *The Song of Roland* was taking shape as a written text, stories and songs about the encounters of Guillaume d'Orange (the aforementioned Saint William of Gellone) were being composed, extending tales of heroic combat into Provençal terrain. For

pilgrims (thinking about) traveling the route from Arles toward Compostela, the *Guide*'s account of tombs and shrines supplied a topographical narrative of miraculous activity analogous to the one the Gospels provided for those journeying along the easternmost shore of the Mediterranean.

The route with the most places to visit passed through Tours; these sites are presented as containing the most auspicious and beautifully decorated shrines. The glittering, gem-studded metal sarcophagus of Saint Martin, fourth-century bishop of Tours, is said to be installed in an immense structure "similar to the church of the blessed James," and, like it, "executed in admirable workmanship." The characterization alerts the pilgrim to what lies at the end of the road. In Poitiers, the venerable bones of Hilarius, that city's fourth-century bishop, reside in another tomb "excessively decorated with gold, silver, and most precious stones" and housed in a "large and beautiful basilica." A large church, not far away at Saint-Jean-d'Angély, shelters the head of John the Baptist. Some religious men had "transported it across sea and land" from Jerusalem, warding off ocean perils in one part of the journey and restoring dead people to life in the other. Pilgrims would have made a connection with James's remains, which, according to legend, had also been transported by boat from the Holy Land for burial in Iberia. At Saintes, a vast church protects the remains of Bishop Eutropius. His life is recounted at considerable length, beginning with his conversion to Christianity as a high-born youth in Persia, followed by his travels to the Holy Land, where he arrived on the day Jesus transformed the loaves and fishes (Matthew 14:15–21). For a medieval reader, the lofty claim pointed to the potency of Eutropius's life, in the way that gilded book covers were perceived as exalting the texts they contained and bejeweled shrines were understood to

proclaim supernatural powers hidden within them. To a present-day reader accustomed to the use of narrative frames in literary works, the assertion that the author's account of Eutropius's life had its source in a text he found in Constantinople and translated from the original Greek hints at the tale's fictitious origin.

The pilgrim retreats through time as he proceeds through the terrain, encountering different sorts of dangers. The place where Roland and his companions, along with Charlemagne's other warriors, fought, died, and were buried in the eighth century was fraught with other obstacles in the twelfth. According to chapters 6 and 7 of the *Guide*, poisonous streams, crooked toll collectors, immoral inhabitants, and individuals speaking an odd language that we understand to be Basque confronted pilgrims after crossing the Pyrenees. These hardships and inconveniences scarcely compared to the tortures and torments holy men and women experienced during the early days of the Church, accounts of which are imbricated with tales of their healings in chapter 8. These stories situated saintly power within the landscape the pilgrim passed through on the way to Compostela, transforming an expanse of disconnected and potentially dangerous sites into one unified by miraculous presences (and pretensions). Consecration of the countryside from the shores of the Rhône to Compostela took the pilgrim through the equivalent of a cemetery *ad sanctos*, a burial ground filled with the bodies of those seeking benefits through proximity to the tomb of an indubitably holier figure. The Alyscamps, where well-to-do people had sought burial near the remains of Arles's early martyrs, was originally such a place.

Suddenly, a text considered by most scholars and writers to be the record of a devotional journey to Compostela made for the use of others undertaking the trip strikes the reader as being

something other than what it has long seemed to be. A letter appended to it, allegedly written by Pope Calixtus II and certifying that "those things written here many people still living attest to be true" is unconvincing. The way information is presented, riddled with gaps, replete with linguistic errors and rhetorical flourishes, hints at another purpose. Like the account of the voyage the *Guide* provides, the text's own history is episodic and, in parts, elusive.

The *Pilgrim's Guide* forms the last section of a volume belonging to the cathedral in Compostela. Some call the tome the *Liber Sancti Jacobi*, because of its focus on the life and legend of Saint James; others refer to it as the *Codex Calixtinus*, in view of the letter attached to it; a few refer to it as *Jacobus*. Its five parts were composed at various times and revised when they were brought together in the decade before 1150. While copies of some sections quickly found their way to other churches, the text of the journey to James's shrine did not proliferate to the same degree. At some point, the parchment pages on which it was written were separated and forgotten, left to languish in the archives of the apostle's church. James's remains had also fallen out of sight, vanishing during an episode of unrest in the church's history. In the 1880s, shortly after the relics were recovered and returned to view, the itinerary for the journey to the tomb was rediscovered and published. Once text and bones were reunited, a new chapter opened in an old tale of travel to the saint's shrine.

Various groups found value in celebrating the contents of the recently rediscovered (and newly named) *Pilgrim's Guide*. The Spanish government adopted the story of the pilgrimage to project a sense of national identity; the Church lauded it as a model of pious behavior; historians found in it an explanation

for literary and artistic developments in the years around 1100. After the Second World War, the journey to Compostela began to be promoted as a stimulus for European reunification. Reattachment of the *Guide* to other books in the compilation, which occurred in 1960, stimulated the production of translations; these brought attention to other aspects of the text. Some anthropologists studying ritual practices saw stages of the pilgrimage as opportunities for the formation of personal and group relationships; others interested in social dynamics emphasized the recreational potential of the devotional journey. Individuals hiking or biking the portion of the route that starts in the Pyrenees still pursue the path outlined in the *Guide*, staying in hostels and carrying a passport in which decorative stamps identify the places at which they stop. The activities of these pilgrims, as recounted in books, blogs, and films, have benefited the modern travel industry in the way that visits to shrines provided prosperity for the Church in previous centuries, through fees levied in exchange for services. The popularity of the Camino, as the journey to James's tomb is locally called, ineluctably contributed to the manuscript's theft from the cathedral in July 2011. A year later, the parchment folios were found in a nearby garage, returned to the archives, and displayed anew, under enhanced conditions of security.

One scholar's scrutiny of the volume to which the *Guide* belongs emphasized its "faulty Latin, quite unlike any other bad Latin," something others have neglected to examine as closely or to take as seriously. Christopher Hohler's demonstration of the multiple instances of grammatical error, wrong usage, and incorrect citation permeating the whole has been largely overlooked in later commentary, its specificity posing a challenge to anyone lacking sufficient proficiency in medieval Latin. Yet his

conclusion, that the text could have served as a tool for teaching language literacy, is apt for a time when forms of speech and communication were in flux. Latin had diverged into spoken and written versions long before the twelfth century, with Romance, its oral form, slowly coalescing into a few distinct languages. From about 1100 on, passages in the vernacular appeared within Latin texts; at the same time, poems were being composed in recognizable forms of French and Spanish. In 1143, a charter confirming the claims of the count of Toulouse to the church and cloister of the cathedral of Arles was written in Provençal. Use of the regional tongue was a way of reinforcing secular authority; once again in use on local street signs, it affirms the persistence of regional identity.

These rapidly changing circumstances also involved transformations in the uses of writing. The *Guide*'s curious comment regarding inscriptions on sarcophagi in the Alyscamps should be read in this light. Its characterization of them as bearing "Latin letters... in an incomprehensible language" presents us with the experience of an individual learning to read, when the alphabet has been mastered but vocabulary is limited and grammar is imperfectly understood, the sort of person for whom the *Guide* may have been written. The comment also suggests that the inscribed words no longer communicated whatever claims they originally made. Erosion of trust in the authority of public writing had begun earlier in the Middle Ages. By the twelfth century, belief in the power of ink on parchment was gaining ground, even for those who were not able to read. Writing and the codices in which texts were collected were being accepted as bearers of truth. The image of a book in Christ's hand, as seen in the tympanum at Arles as well as on countless other churches, expressed that belief. Today, nothing about texts of that time

can be known with such certitude, because many, if not most, survive only in the form of later copies, and often these are inserted into collections of other material. Without knowledge of the way in which a text was originally produced, it is difficult to ascertain the reliability and import of later transcriptions. Like the author of the *Guide* confronting writing on sarcophagi in the Alyscamps, we may be able to read words in a text without appreciating what they were intended to mean.

A few decades after its rediscovery, the *Pilgrim's Guide* was described as "a paper-bound pamphlet of a few badly printed pages [that] has guided scholars toward the solution of their difficulties, much as the stars of the milky way reminded the mediaeval sinner of the road to Compostela." The author of those words, the American archeologist and architect Arthur Kingsley Porter, was referring to the work of philologists and literary scholars who had identified the routes enumerated in the text as the means by which troubadours spread stories and songs while traveling between churches and courts. He doubled down on their argument, using it to explain similarities among sculptures on different churches, turning an academic observation about the movement of itinerant poets into a mystical pronouncement likening artistic activity along the roads to a "cosmic phenomenon" that "overwhelms with the sense of its force."

The "badly printed pages" provided Porter with the template for an argument establishing a claim about the pilgrimage's centrality in the propagation of Romanesque art. His comparison of the pilgrimage road to a "great river, emptying into the sea at Santiago [de Compostela], and formed by many tributaries," adapted imagery from the *Pilgrim's Guide*: Trophimus's Christianizing mission is described in that work as the "clearest of sources" from which "Gaul received streams of Faith." In Porter's

writing, the fluvial analogy treats the roads as natural manifestations of pure devotion, comparable to the channels through which Christianity took root. His remark that the twelfth-century text turned readers into pilgrims experiencing the path to James's shrine through its writer's eyes anticipated the role modern readers would assume with relation to his own work. As we leaf through the hundreds of photos Porter and wife, Lucy, took as they traveled the roads in the comfort of their car in the aftermath of the First World War, photos they then published in volumes attached to his text, we see what they saw, becoming as we do so witnesses to their work's claims.

The strategy of making a reader, or a viewer, see things through another's eyes engenders an experience recommended in the twelfth century for those unable to visit sites central to Christianity's story. It allowed individuals to follow Christ's footsteps to places touched by His presence, "with feelings not with feet," as Bernard of Clairvaux said at the time. Monks were especially encouraged to perform surrogate enactments of travel in order to avoid the distractions of wanderlust and maintain the discipline of their orders. Vivid descriptions in Crusader writing enabled readers to feel as though they had been to Jerusalem; in some places, sculptures abetted this practice. A group of capitals salvaged from a cloister in Toulouse presents exceptionally lively depictions of events transpiring during the last week of Jesus's life. Precisely delineated architectural details define the chambers in which Jesus washed Peter's feet, sat for his last meal, and was laid to rest. As originally installed beneath the arcading of the walkways in the monastery of La Daurade, the carvings enhanced the monks' sense that they were peering at miniature replicas of hallowed sites nearly three thousand miles away, transported through space as they were taken back

in time. At Santo Domingo de Silos in Spain, the arcaded frame around a large relief depicting Christ with two travelers on the way to Emmaus makes the figures appear to be moving through the cloister walk in which the viewer stands (see figure 9). The cockleshell on the bag Christ wears presents him as someone who has been to Compostela, making the experience of pilgrimage to the apostle's tomb particularly palpable for residents of the cloister who were dissuaded from traveling there to see the shrine for themselves, even though the road to James's church passes through Burgos, only thirty miles from Silos. Compostela lies less than three hundred miles from there.

As the capstone of a compilation devoted to perpetuating James's memory, the *Pilgrim's Guide* adheres to the format of the other sections in which the apostle is celebrated through regularly repeated performance—the saying of sermons, the singing of chants, and the recounting of deeds. The fifth book complements these texts with the script for another enactment, a carefully choreographed, imagined journey to the saint's tomb, akin to those occurring in many monasteries. Rather than being written as a Baedeker for the use of those making overland pilgrimages to James's tomb, as is usually said, the last portion of the compilation memorialized the journey, establishing textual proof of the apostle's sanctification of terrain from the shores of the Rhône, where Christianity's mission had been established in the third century, to the outermost edge of Iberia. The grammatical errors Hohler noted served a rhetorical function, making the text more memorable.

JOURNEY'S END

The identification of Arles as the first place on the pilgrim's itinerary provides the voyage to Compostela with temporal and topographical features foreshadowing things encountered at the journey's end. The remains of a particularly venerable holy man and a cemetery littered with marble tombs figure in both the description of Arles and the legend of James's life, versions of which were recounted to pilgrims through songs and stories at his shrine. Awareness of this shapes our sense of what we are reading, making book 5 of the *Liber Sancti Jacobi* seem even more like a calculated tale.

In chapter 9 of the *Pilgrim's Guide*, the reader is presented with the church housing the apostle's tomb as seen from a distance. Enumeration of its gates, along with a recitation of the measurements of its walls, recalls the description of the heavenly city in Revelation (21:12–21), without including the holy text's references to precious materials. In their place, the sculp-

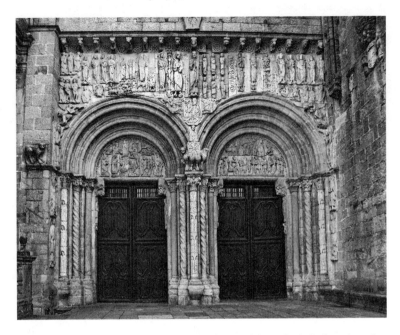

Figure 36. Puerta de las Platerías, south transept of the cathedral of Santiago de Compostela. Photo by Wikimedia Commons user Amadalvarez (CC BY-SA 3.0), https://creativecommons.org/licenses/by-sa/3.0/legalcode.

tures decorating the limestone portals on the transepts of the church are described in awe-inspiring detail; no other church along the way to Compostela is presented in this manner. The *Guide* notes that columns, some of which are made of marble, frame the entries, while depictions of the Lord, the Virgin Mary, Evangelists, apostles, and angels, surrounded by a profusion of zodiacal figures and floral motives, decorate surfaces all around (figure 36). In places, the carvings are too numerous for the writer to describe.

A comparable array of like figures and forms—Christ enthroned, the Virgin, apostles, columns, and vegetation—has already been encountered by the reader on the large metal reli-

quary in the church of Saint-Gilles-du-Gard, to which the pilgrim was directed immediately after leaving Arles. If this has been forgotten, the effusive enumeration of similar subjects on and around the doorways at James's shrine stimulates recollection. More likely memory, however faint, of the sumptuous shrine that marked the journey's point of departure has kept details of the reliquary alive in the reader's mind, ready for recall when the majestic edifice built over James's tomb appears at the voyage's end. Upon arrival in Compostela, the shared elements merge, forming an image surpassing anything seen elsewhere along the roads: a massive reliquary-shrine exceeding all others in size and outshining them in brilliance, within which rests the marble tomb containing the apostle's remains. The trajectory of the pilgrim's passage has unspooled between mirror-image memorials, with the greatest of all holy containers providing the inevitable conclusion for a text that seeks to justify rather than just describe the journey to Compostela. In its opening lines it already betrayed its persuasive rather than probative intentions by urging the reader to surrender to the truth of what is said "without hesitation."

Real pilgrims arriving at the church could not have participated in the experience the text narrates, because the church was either being repaired or under construction for much of the twelfth century, and it was far from completion when the *Guide* was written. Visitors may have been led toward reflections or imaginings similar to what the text describes as they stood on the threshold of one of its entries by clerics who had studied scripture and were trained in the rules of rhetoric that Mary Carruthers has taught us to appreciate. At various places these men offered guidance to visitors, enhancing and conceivably correcting meanings listeners and viewers were discovering for

themselves. The writer of the *Guide* assumes the stance of such an individual when he refers to a relief of a woman holding a skull in her lap that he saw on the southern transept, explaining what those hearing him were supposed to see (figure 37):

> [She] holds in her hands the filthy head of her lover beheaded by her own husband ... [, who] forces her to kiss it twice a day. Oh, what a great and admirable punishment meted out to the adulterous woman, to be recounted to everybody!

His words and their feigned consternation recall those in anathemas condemning anyone attempting to deface a holy book or destroy a sacred object. The admonition inscribed on the shrine at Saint-Gilles-du-Gard warned that whoever might break it risked being cursed eternally by none less than God, Saint Gilles, and the entire holy order. The shrine was destroyed, but no one can say whether the words worked.

The white marble plaque the writer describes is situated at the right edge of the tympanum over the left-hand door of the Puerta de las Platerías, the place where silversmiths hawked their wares. Trimming along its edges indicates that it was planned for a different situation and then cut back to fit the curvature of the archivolt into which it was subsequently inserted. Repositioning of the piece had already occurred by the time the *Guide* was written, so we do not know where the relief previously was, or what significance it had in that situation. High up on the wall above the double doors, it would have been harder to see; alongside fantastical beasts or oddly dressed mythological creatures, its forms would likely have been understood differently. The new location, next to depictions of Jesus's Temptations, created the conditions for the singular message attached to it in the text. Yet the speaker may not have been admonishing the

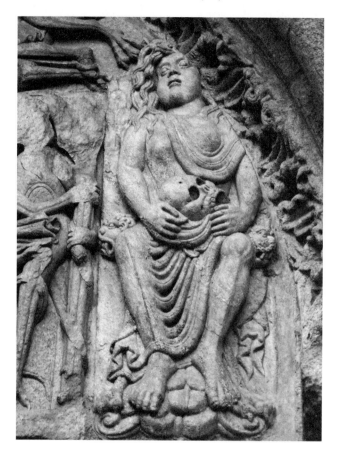

Figure 37. "Adulteress," detail of tympanum above left door of Puerta de las Platerías, south transept of the cathedral of Santiago de Compostela. Photo by Wikimedia Commons user Alma (CC BY-SA 3.0), https://creativecommons.org/licenses/by-sa/3.0/legalcode.

reader about licentiousness per se. He may have been addressing the varied opportunities for misbehavior that lurked in the vicinity of the doorway, where trinkets were being sold. As someone trained in rhetoric, he understood that dramatic or unusual images readily took hold in a viewer's mind, helping to fix in memory what was said about them. Compelling imagery could

convey a message beyond anything words alone communicated, as the Cistercian abbot Bernard of Clairvaux was aware when he warned his Benedictine brothers about the dangers of the attractive, distracting carvings in their cloisters. Depictions on the outer faces of Arles's portal functioned in a similar fashion.

The image of the woman holding the skull remains in place for visitors to James's church to see and for tour guides to explain. Mention of it in the *Guide*, together with exaggerated accounts of "barbarous" language and unseemly behavior among the Navarrese and the Basques, who would "kill a Frenchman for no more than a coin," reinforce our engagement with the text as we read. Along with detailed descriptions of the reliquary at Saint-Gilles-du-Gard and the entries to James's church, these passages sear the journey to Compostela into memory, so that the pilgrimage will never be forgotten.

According to Isidore's *Etymologies*, things that "admonish the mind to remember" should be called "monuments." The church over James's tomb was built by the archbishop of Compostela with that in mind, and the final book of the collection known as the *Liber Sancti Jacobi* was composed, I propose, for the same reason, so that the voyage to the saint's remains would never be forgotten. In this instance, the words worked. To this day, pilgrims continue to come to the church, many with the *Guide* in hand, following the footsteps, real and imagined, of those who have gone there before. The Bishop of Seville, whose tomb in León is the final one the *Guide*'s pilgrim visits before arriving at Compostela, once again has the last word.

AFTERWORDS

As I explored the *Pilgrim's Guide*, all the while reflecting on a painter's ruminations, I arrived at places I had not thought of going. Vincent's comment on Saint-Trophime's portal is buried in one of his long letters and is seldom cited by writers interested in his art. I came upon it in the text of one of Meyer Schapiro's talks on Romanesque sculpture, having forgotten that I had heard it while attending those lectures decades before. The comment hadn't registered for me then. While it was intriguing to know that a modern painter had taken note of medieval art, the associations the carvings conjured up for him seemed to belong to a Middle Ages different from the one I was encountering in my own work. Moreover, the portal's dark and dreary appearance had turned my interest early on toward livelier Romanesque sculpture on roads leading away from Arles, in the directions of Toulouse and Vézelay.

Once the portal was cleaned, I became fascinated by its pro-

fusion of materials and stories; Vincent's spirited reaction to it acquired new resonance. His reference to the "world of Nero" aligned him unwittingly with the majority opinion, that its figures copied ancient statuary. This point of view was epitomized by Erwin Panofsky, a half century after Vincent wrote his letter, in a well-known study of antique revivals in European art. The distinguished scholar asserted that twelfth-century sculpture in Provence—and specifically in Arles—was "dangerously close to unimaginative duplication" of the region's ancient remains. His words, which still inform discussions of the portal and work at churches nearby, haunted me as I reengaged with Saint-Trophime, trying to comprehend its sculptures' undeniably skillful imitation of Roman forms in a less dismissive way. While I didn't know whether or how Vincent's remarks would help, I decided to look more deeply into them, curious to find out what had led him to react to the portal in the way that he did.

The path to the study of medieval art in the nineteenth century has long been through Prosper Mérimée, better known to many as a storyteller and the librettist of *Carmen* than for his archeological work. As the first inspector of France's historical monuments, his remarks on the churches he visited in the 1830s provide important information about how these buildings appeared before the program of restoration that he initiated got underway. His writings, along with archeological reports of the time, helped me understand what remained of Arles's ancient fabric before Vincent went to live there, creating for me a place that existed but that I had never seen; like Vincent's Japan, it shaped my thinking. As I explored these texts, I also chased after the things Vincent was reading. Something I encountered as I scrutinized one of his beloved books reminded me of the danger of relying too heavily in one's work on what others have said.

The book Vincent was reading when he wrote the letter to Theo commenting on the portal was Maupassant's *Pierre et Jean*, a short novel about family secrets and the rivalry between brothers; it had just been published. Vincent called the book beautiful but said nothing about its characters or its plot, as he had when he recommended *Bel-Ami*, an earlier book by Maupassant, to his brother and sister. Instead, he remarked on the author's preface to the book, entitled "The Novel," in which Maupassant reflects at some length on the nature of art. Vincent was impressed by its explanation of "the freedom the artist has to exaggerate, to create . . . a more beautiful, simpler, more consoling nature," as well as by what "Flaubert's phrase might have meant, 'talent is long patience'—and originality an effort of will and intense observation."

When I consulted *Pierre et Jean* to verify Vincent's transcription of what he had read, I too was taken by Maupassant's words. Elaborating on what Flaubert meant in saying "talent is long patience," Maupassant suggested that it was a question of "looking at everything one wants to express long enough and with enough attention to discover in it an aspect that no one has seen or spoken about. There is, in everything," he continued, "something of the unexplored, because we are accustomed to using our eyes only with the memory of what people before us have thought about the things we are contemplating."

I had long depended on the text of the *Pilgrim's Guide* for information about devotional activity in southern Gaul and Iberia in the twelfth century, assuming that it had been some sort of diary, written as a handbook for the use of pious travelers making the trip to James's tomb. Writers even before Porter had suggested as much, and the scholarly cohort to which I belonged did not question that claim. On three occasions, I had taken a copy of the text with me as I traveled to Compostela, using it to

explore the church and study its portals. The first time was in the summer of 1965, when a grant enabled me to travel along portions of the pilgrimage roads. Other things I saw distracted me and I didn't get to either Arles or Compostela on that trip. Still, I feel compelled to acknowledge receipt of Harvard University's support back then. It stimulated my thinking about the roads to James's shrine in the following years, during which my perspective on many matters was being broadened by the work of colleagues at the University of Chicago.

Decades later, after rereading the text of the *Pilgrim's Guide* countless times in connection with classes I was teaching, the role played by Arles as the starting point of the pilgrimage stood out as a matter worth interrogating. As I studied the passage concerning the Alyscamps, I didn't anticipate that the way in which I came to read it would alter the way I perceived the entire little book, transforming what I had once taken to be a sincere and helpful, if erratic, account of worldly activity into a deliberate—if unartful—narration of an imaginary voyage. As I connected the text to other things I was reading and thinking about, I came to see it as pseudo "documentation" of a practice performed in James's honor, complete with scriptural citations, allegorical allusions, and rhetorical embellishment to make it more memorable. Composed more in the manner of a meditation of the heart than as a guide for feet on the ground, it provided the compilation of which it was a part with additional affirmation of James's sanctity by demonstrating his ability to draw the faithful to his tomb.

I also could not have foreseen that a relatively recent denizen of Arles, someone who had briefly lived there long after the portal was put in place, would become my guide through the city's streets, helping me perceive memories of those who had

previously passed through as active presences in the city's history instead of as fossilized participants in a sedimented story. For a long time, I had wondered how my fascination with Vincent's words, beyond those with which he described the portal, would come together with my study of the sculptures and the city. Once again, something he said showed the way:

> But what's your ultimate goal, you'll say. The goal becomes clearer, and takes shape slowly and surely as the rough draft becomes a sketch and the sketch a painting, as one works more seriously, digs further into the originally vague idea, the first fugitive, passing thought, until it becomes fixed.

At the urging of Gauguin, Vincent came to realize during his stay in Arles that the task of realizing what the eye picks out from its surroundings is a slow and arduous one and cannot be foreseen at the outset of one's work. It comes into view bit by bit, the more one clarifies certain elements and acknowledges the discordant nature of others. In many instances, he erased or altered visual evidence in favor of an image he had in his mind, reworking paintings and making new versions of them to capture more effectively what he remembered having seen. He did several paintings of the bridge over the canal, his bedroom in the yellow house, and the allée in the Alyscamps, but he painted only a single canvas of the café bordering the square near where Arles's forum once stood, concentrating in it on the "little figures of people drinking [and] a huge yellow lantern [that] lights the terrace, the façade, the pavement, and even projects light over the cobblestones of the street" (see plate 8).

The unforgettable yellow-and-blue picture he produced, with its star-studded sky, lacks the ancient columns that were so criti-

cal for my understanding of ancient Arles but irrelevant to Vincent's interest in a street-side terrace one brilliant September night. What he saw had made him think of Maupassant's description in *Bel-Ami* of lighted cafés along the boulevard in Paris on a similar starry evening. Henry James had viewed the place differently, and so did I; there was no single way of seeing or recalling it. Although I worked as Vincent said he often did, pursuing an initially uncertain idea until it became fixed, I preserved impressions of things that came into sight instead of deleting them, imagining them as pentimenti in old paintings, faded traces of earlier images that continue to inform what we see.

There was scarcely a moment over the course of the last decade when some aspect of the portal and the pilgrimage to which it is legendarily bound was not on my mind. Everything I read and everyone I talked to contributed in some way to what I was writing, the work of former students well launched on their own pursuits as well as that of colleagues, known and unknown, whose publications informed my thinking, and friends, whose patience I'm sure I tested, as I sought to make sense of what I was discovering. There is neither space enough here nor time to acknowledge my debt to all of them. Research regarding the city's history, the church's archeology, and the devotion to Saint James, initially done in the recesses of libraries, was completed remotely as my manuscript neared completion, when a global malady mandated access to books online. Works I consulted, particularly about the pilgrimage to Compostela, are well known to scholars engaged with the issues I have addressed and repeated references to them would have been cumbersome, slowing reading and distracting from an unfolding argument. Additionally, many of the texts I have cited are readily available through the internet, however imperfect it may be as a reliable

resource. Isidore's *Etymologies*, a PDF of the *Pilgrim's Guide*, Bernard's writings, Vincent's letters, are all commands away. The need for me to provide bibliographic guidance to the reader no longer exists in the way that it did when I began this work nearly a dozen years ago.

In 2008, Arles's archeological history, uncovered stone by stone and reported bit by bit in local scholarly journals, was compiled and compressed into a volume of over thirteen hundred pages by a team of scholars under the direction of Jean-Maurice Rouquette. *Arles: Histoire, territoires et cultures* is a monument to the work of countless individuals, amateurs as well as academics, in celebration of the city's two thousand years of existence. Its bulk attests to its comprehensiveness and the importance of the information it contains, in the way that the appearance of medieval books affirmed the truth of their contents. I have relied heavily on my copy of it, a generous and thoughtful gift from Risham Majeed, to verify innumerable details as I put final touches on my manuscript and collected data for use in the maps that accompany it. The story the tome tells is, of necessity, divided into historic segments that the reader must piece together, like parts of a puzzle, if she is to have any sense of how Arles appeared and was perceived at given moments over the course of the centuries. That is what I needed to know to understand the portal, and the volume proved invaluable in helping me assemble the picture of Arles, *as it was*, that I have constructed here.

As I pursued my work, Vincent was becoming a far greater force than he had been when I began thinking about Saint-Trophime. Julian Bell's *Van Gogh: A Power Seething*, which appeared in 2015, immersed me in Vincent's thoughts and writing and led me to read his letters more thoroughly than I had ever

done. As my manuscript neared completion, I discovered Mariella Guzzoni's *Vincent's Books: Van Gogh and the Writers Who Inspired Him* (2020). Its chapter "On Provence" focuses on different books Vincent read during the time he lived there, in particular on Alphonse Daudet's *Tartarin de Tarascon*, which I remember having read as a schoolgirl. Lydia Davis's brief, collage-like essay on moments in Arles's history, many of which figure in my own work, appeared in time for me to include it here among works that enrich one's sense of the place that transformed Vincent's artistic practice; it is included in *Essays Two: On Proust, Translation, Foreign Languages, and the City of Arles* (2021). None of these writers saw things as I did or said what I had said, but each affirmed what I knew and had tried to express, that the study of Vincent's words and Arles's monuments is unexpectedly and infinitely rewarding, both for what they have to say about the painter and the city and for the entrées they provide into an array of other matters.

Vincent's engagement with Arles helped me experience the city and the work he did there through the filter of things that had happened in it over the course of its long history. One of the first paintings Vincent did in Arles, of the front of a sausage shop as seen from the window of the café in which he was sitting, made me think of butchers' stalls in that area centuries before, selling meat from animals that grazed on the surrounding terrain of the Camargue, where cattle and horses are still being raised. The stem of a flowering almond tree that Vincent brought home one early March day, placed in a simple glass, and rendered twice suggested the mulberry branches pilgrims took away from the tree near Genesius's column. As those travelers had thought long ago, Vincent too hoped the flowering boughs he painted would bring improvement to his life. The cypresses

in Arles's gardens under which Vincent imagined medieval poets strolling made me think of Henry James, whose fondness for cypresses led him, on occasion, to see them where they weren't. And Vincent's drawing (as well as a painting) of the fortified church of Notre-Dame-de-la-Mer, in the village of Saintes-Maries-de-la-Mer, on the seacoast twenty-five miles from Arles, reinforced my sense of the part pilgrimage has played in the region for more than a thousand years (figure 38). Perhaps Vincent was inspired to go there at the end of May 1888 after hearing about the procession of gypsies that had traveled there a few days before to venerate the relics of Saint Sarah, the dark-skinned servant who is said to have accompanied the three Marys on their flight from the Holy Land to escape persecution. Medieval legends recount how Mary Magdalene, along with the lesser-known Marys (Salome and Cleophas) and Sarah, patron saint of the Romani, arrived on the shores of Provence in a boat at an uncertain date in the first century. According to the Magdalene's earlier and better-known story, her relics made their way to Vézelay. Later texts describe the adventures of the two other Marys and Sarah, while vintage postcards and recent videos testify to the popularity of the annual pilgrimage to the church in which their remains are purportedly enshrined.

In earlier times, a saint's story would have been recounted in the liturgy sung on his or her feast day; James's deeds, collected in the *Liber Sancti Jacobi* in Compostela, are still set forth in his church on July 25. In many places, ex-votos and other offerings additionally attest to a saint's ongoing power. A small panel in Notre-Dame-de-la-Mer, illustrating Claude Obert's fall from a horse, has a text announcing his miraculous deliverance from the accident along with the date, May 25, 1853. In the area around Arles, this was the feast day of Mary Cleophas, known

Figure 38. Vincent van Gogh, *Les Saintes-Maries-de-la-Mer*, 1888. Pencil, quill pen, and brown ink on paper, 43.5 × 60 cm (17⅛ × 23⅝ in.). Courtesy of the Oskar Reinhart Collection "Am Römerholz" in Winterthur, Zurich Canton, Switzerland.

locally as Mary Jacobe (figure 39). In the painting, she and Mary Salome sail toward the shore on which they are said to have landed while three white horses, representatives of a breed indigenous to the region, surround the body of the fallen Claude; he appears to have been heading away from the church that looms in the distance. If we imagine that Claude had just left the sanctuary when the accident occurred, then we recognize his recovery as a reward for devotion. Whether the accident, the cure, or the expression of appreciation occurred on the specified day is not clear. Uncertainties abound, as they invariably do in the lives of all saints and in the testimonies subsequently written and painted in tribute to them. Nonetheless, this depiction of a mishap overcome with the help of the Marys' intervention con-

AFTERWORDS {143}

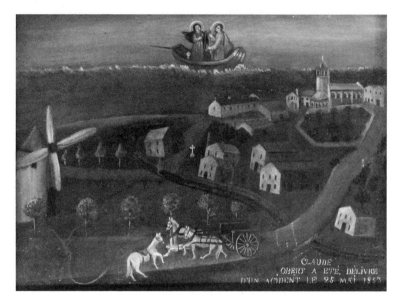

Figure 39. Ex-voto 24 in the church of Notre-Dame-de-la-Mer, in Saintes-Maries-de-la-Mer, offered on behalf of Claude Obert for being saved after falling off a horse on one of the saints' feast days, May 25, 1853. Photo by Wikimedia Commons user Finoskov (CC BY-SA 4.0), https://creativecommons.org/licenses/by-sa/4.0/legalcode.

stitutes a perpetual display of gratitude, along with the wish for continued protection from recurrent danger. Worshippers pausing to look at the little panel bear witness to its painted story, validating it in the way that pilgrims passing Saint-Trophime's portal, seven hundred years before, were urged by its carvings to do. Like those earlier visitors, we testify to Vincent's continued presence as we follow his footsteps around Arles and its countryside. In a region long associated with mythic and historic heroes, he has become, for now, its most memorable passerby.

This book came together under Susan Bielstein's knowing and supportive eye. No words of appreciation can adequately ac-

knowledge how important her encouragement has been for this project, as those who have been lucky enough to work with her will not be surprised to hear me say. Dylan Joseph Montanari's editorial assistance facilitated the text's realization, something I couldn't have managed on my own, wrestling for a while with inadequate Wi-Fi at a cottage in rural Maine and then, back home, with computer programs that will never be a lingua franca for me. Kate Blackmer's attention to accuracy made me grapple with facts on the ground as she prepared the maps that visually guide the reader through Arles's remains, real and remembered. And, finally, Stephen Twilley's laser-like eye made me think more carefully about things I had already thought about countless times. I was incredibly fortunate to have had their expert encouragement and help and am so grateful for it, as I hope the reader will remember to be too. Books, invariably lonely in their conceptualization (and invariably longer than expected in their materialization) are necessarily collaborative, well beyond what a reader is likely to imagine.

INDEX

Page numbers in italics refer to figures.

A
Abraham's bosom, 98
actors, 68, 80, 88
Acts (book of the Bible): 7, 93, 95
Adam and Eve, 99
"adulteress," detail of Puerta de la Platerías, 130–132, *131*
Agde, 116
Agrippa, Marcus Vipsanius, 60
Agrippina, 84
Ahenobarbus, Gnaeus Domitius, 59
Aix-en-Provence, 117
Alhazen, 20
Alps, 56, 60
Alyscamps, 1–2, 43, *44, 45,* 45–49, *47,* 57–58, 68, 98, 102, 104, 109, 120, 123–24, 127, 136–37, map 1, plate 1
Alyscamps, The (van Gogh), 1, 45–46, 48, plate 1
Amphitheater/arena, 1, 12–13, 16, 42–43, 63, 68–69, *69, 70,* map 1
Amsterdam, 38, 55, map 2
anathema, 115, 130
ancient structures, 61–69, 72–75
Andrew (apostle), 92
animal cultivation, 53, 108–9
animal skins, 108–10
antiquity: imitation of, 85, 134; interest in, 85–86

Antwerp, 28
Aphrodite of Arles. *See* Venus of
　　Arles
arches, 61, 65
À Rebours (Huysmans), 31
Arelate, 52
Arena at Arles (van Gogh), 13, *16*
Arles: Histoire, territoires et cultures
　　(Rouquette), 139
Arlésienne, L' (van Gogh), 22
Arlésiennes, 35
Arles: View from the Wheatfields
　　(van Gogh), 12–13, *14*
art market, 4, 40
Asia Minor, 51
assignations, 43, 112
Aude River, 59
Augustine, Saint, 86
Augustus, 59–63, 65–66, 80, 82,
　　84, 106
Aula Palatina (Trier), 67
Aurier, Albert, 37–38, 50
Ausonius, 57, 68–69
Autun, 74
Avignon, 10

B

Badilo (monk), 117
Baedeker, 126
Baldus, Édouard-Denis, photographs by: *Church of Saint-Trophime*, 27; *Entrée du Robinet*, 3; *Roman Cemetery (Alyscamps Necropolis and Church of Saint-Honorat, Arles)*, 47
Balzac, Honoré de, 34–35; *Le Père Goriot*, 34
Barcelona, counts of, 116
Barr, Alfred H., Jr., 38–39
Bartholomew (apostle), 95
Basque, 85, 120
Baths of Constantine, 66, 73,
　　map 1
Baudelaire, Charles, 29
Baux family, 82
Beaucaire, 106
"beautiful deformities," 35–36
Bede, Venerable, 96
bedroom, Vincent's in Arles. *See*
　　yellow house
Beecher-Stowe, Harriet, 25
behavior: deviant, 111–12; mis-,
　　131–32; model for, 96–102,
　　112; pious, 121
Bel-Ami (Maupassant), 23, 135, 138
Bell, Julian: *Van Gogh: A Power Seething*, 139–140
Bernard, Émile, *7*, 23, 25
Bernard of Clairvaux (abbot), 35–
　　36, 125, 131–32, 139
Bible, 25. *See also specific books of
　　the Bible*
blessed. *See* saved
Boccaccio, 5, 9–10
Bois des Lens, 106
Bonger, Jo (Vincent's sister-in-law),
　　23, 38

book covers, 119–120
Book of Optics (Alhazen), 20
Bordeaux, 57, 59, 68, map 2
Bordigalia, 59. *See also* Bordeaux
Botticelli, 9–10
bridges, 2, 6–7, 47, 57–58, 61, 65, 95, maps 1 and 2
brothels, 35, 43. *See also* prostitution
Brown, Peter, 97–98
Burgos, 126
butchers, 108–9, 140

C

Caesar, Julius, 52–55, 59–60, 84–85; *Commentaries on the Civil War*, 52; marble bust of, *53*, 53–55, 65
Caesarius (bishop), 74, 109
Café du Forum, 6, 23, *24*, 74, map 1. *See also* Place du Forum; *Terrace of a Café at Night (Place du Forum)*
Caligula, 84
Calixtus II (pope), 121
Camargue, 140
Camille, Michael, 29
Camino, 122. *See also* Santiago de Compostela
Canal de Craponne, 46, maps 1 and 2
canals, 6, 8, 43, 45–48, maps 1 and 2
Canton (Guangzhou), 33

Carbonnières family, 82, 106
cardo, 63, map 2
Carmen (Mérimée), 134
Carolingian. *See* Charlemagne
Carruthers, Mary J., 129
Cartagena, 57
Carthage, 66
cathedral, late antique, 2, 67, 72–74, 86. *See also* Saint-Trophime
cattle, 52, 108, 110, 113, 140
Celtic, 52, 109
cemetery. *See* Alyscamps
cemetery *ad sanctos*, 120
Chaîne des Alpilles, 41–42
Charlemagne, 18, 109, 114–16, 120
Charles IX, 46
Chicago, 39
China, 33–35
"Chinese nightmare," 26, 33–36
Christ, 105, 123, 125–26, 128. *See also* Jesus
Christian imagery, 25–26, 89–99, 104–5, 107, 110–11, 112, 127–32, 141–43
Christianity, 63, 67–68, 74, 87, 90, 92–93, 103–4, 112, 124–26
Chronicle of Pseudo-Turpin, The, 109
Church council, 66, 68
Church of Saint-Trophime, Arles (Baldus), *27*
circus, 65, 69
city governance, 93–95
city markers, 6, 17, *18*

Claudius, 84
cockleshells, 20
Codex Calixtinus, 121. See also *Liber Sancti Jacobi*
coffins. *See* sarcophagi
column of Genesius, 57, 82, 101, 140
columns. *See* kiln; portico of forum; theater; Saint-Denis
Commentaries on the Civil War (Caesar), 52
Compostela. *See* Santiago de Compostela
Constantine (emperor), 43, 63, 66–67
Constantinople, 120
copying, 11, 28, 37, 134
Correggio, Antonio da, 25
Creation, 96, 99
Crusades, 101–2, 118, 125
cryptoporticus, 62–63, 74, map 1
cultural markers, 59, 77–78
cypress trees, 5, 10, 17, 20, 38, 40, 48, 50, 140–41
Cyril (deacon), 67

D
damned, 96–99
Daniel, 110–11
Daniel (book of the Bible), 111
Dante, 9–10; *Inferno*, canto 9, 46
Daphnus, 66
Darius (king), 110–11
Daudet, Alphonse, 140; *Tartarin de Tarascon*, 140

Davis, Lydia: *Essays Two*, 140
De architectura (Vitruvius), 80
decumanus, 63, map 2
deer, 108–9, 114
Delacroix, Eugène, 25
Delilah, 110
destroyed sites, 6–10, 16, 69
deviant behavior, 111–12
De vita Caesarum (Suetonius), 54
Diocletian, 66, 116
Donatism, 66
drawbridge, 6–8, *137*. See also Langlois Bridge
Drawbridge with Walking Couple (Langlois Bridge at Arles) (van Gogh), 6–8, *7*, map 2
Duc de Berry, 12, 15, 74
Dürer, Albrecht: *Melencolia*, 31
Dutch peasants, 39

E
Emmaus, 126
Entrée du Robinet (Baldus), 2, *3*
Ermengard (viscountess), 117
Essays Two (Davis), 140
Etymologies (Isidore), 86–88, 112–13, 132, 139
Eutropius (bishop), 119–20
exhibitions, 4–5, 22–23, 33–34, 38–40
ex voto, 141

F
Falling Leaves (Les Alyscamps) (van Gogh), 43, 45, *45*

fame, 5–6, 8–9, 17–18, 22–23, 37–43
Félibres, 77–78
Fénéon, Félix, 40
Financial Times, 42
Flaubert, Gustave, 135
Flavian, dynasty, emperors, 61, 63
Flavien bridge. *See* Pont Flavien (Saint-Chamas)
Flavos, Lucius Donnius, 61
Florentia, Saint, 116
Fondation Vincent van Gogh, 22, map 1
forum, 62–63, *64*, 66, 69, 74, 137, map 1; portico of, *64*, 75–76, *77*, 78
François I, 46
French Revolution, 82, 89
friezes, 89, 94–100, 102, 104–5
Fronto, Saint, 118

G

Galicia, 105
Gallia Narbonensis (Provincia), 66
"garden of a poet," 9–10, 11
Garden of Eden. *See* Creation
Gascony, 109
gates, 1, 2, 5–6, 60, 62, 98, 127, map 1
Gauguin, Paul, 1–2, 8–10, 31, 43, 50, 137, plate 4; *Landscape, or The Three Graces with the Temple of Venus*, 43, *44*
Gaul, 51–68, 73–74, 116, 118, 124

Gazette des Beaux-Arts, 12–13
Geary, Patrick J., 115
Gehry, Frank, 40–42; LUMA Arles Tower, *41*
Gellone. *See* Saint-Guilhem-le-Désert
Genesis (book of the Bible), 99
Genesius, Saint, 2, 19, 56–58, 68, 82, 100–101, 140
Genoa, 103
Geographika (Strabo), 56
George, Saint, 82
Germanicus, 28
Gervase of Tilbury, 58, 81–82; *Otia imperialia*, 58
Geryon, 51–52, 113
Getty Museum (Los Angeles, CA), 39–40
Gilles, Saint, 114–15
Ginoux, Joseph-Michel, 22
Giotto, 9–10
Girardon, François, 82
Gospels, 25, 94, 119
Gothic style, 26–28, 31
Gounod, Charles: *Mireille*, 77
Goupil, Jean-Baptiste Adophe, 12
granite, 79–80
Gratia (emperor), 57
Greco-Roman, 58, 110
Greek(s), 52, 55, 84, 107, 113, 120
Gregory (bishop), 58
Guardian Spirit of the Waters (Redon), 31, *32*
Guillaume d'Orange. *See* William of Gellone, Saint

H

Guzzoni, Mariella: *Vincent's Books*, 140

Hague, The, 4
handbook, 135–36. *See also* Baedeker
harbor, 52, 55–56
headaches, 31, 33
healing, 19–20, 57, 67, 120
health, 2, 4, 10, 31
"heartache," 31
Hera. *See* Paestum
Herakles, 51–52, 59, 107–8, 110–11. *See also* Hercules
Hérault River, 116
Hercules, 108, 113
Herod (the Great), 95–96, 100
Herod Antipas, 95
Hilarius (bishop of Arles), 67–68, 86, 104
Hilarius (bishop of Poitiers), 119
Hohler, Christopher, 122, 126
Holy Land, 74, 101–2, 118–19, 141
holy men, 2, 67–68, 73–74, 89–95, 104, 114–20, 127
Holy Sepulcher, 98–99, 118
Homer: *Odyssey*, 51
Honoratus (bishop of Arles), 46, 58
Honorius Augustodunensis, 87
horses, 112, 140–42
Hospitallers, 101–2; church of, map 1
Hugo, Victor, 25, 28–29

Huysmans, J.-K., 31, 33; *À Rebours*, 31

I

Iberia, 20, 51, 59, 113, 116, 119, 126. *See also* Spain
identity, 59, 76, 78, 121, 123
imaginary voyage, 125–26, 136
imitation, of antiquity, 134
Impressionists, 4
Independent Artists, salon/society of, 4–5, 33, 40
Inferno, canto 9 (Dante), 46
internet, 138–39
Irises (van Gogh), 39–40, plate 7
Isaiah (book of the Bible), 96
Isidore of Seville (bishop), 86–88, 112, 132, 139; *Etymologies*, 86–88, 112–13, 132, 139
Italy, 58, 103, 113

J

Jacobus. *See Liber Sancti Jacobi*
James, Henry, 48, 69, 71, 75–76, 79, 88–89, 121, 138, 140–41
James the Great, Saint, 18–20, 51, 74, 95, 119–22, 126, 132–38, 141–43. *See also* Santiago de Compostela
James the Less (apostle), 93
Japan, 2, 33–34, 72
"Japanese dream," 36
Japanese prints, 2, 13, 16, 33–34
Japonaiserie, 33

Jerusalem, 93, 98, 118–19
Jesus: followers of, 74; infancy story, 94–96; miracle of loaves and fishes, 119; movements of, 118; parable of, 96–99; resurrection, 93, 98–99; temptations, 130; washing of Peter's feet, 125
John (apostle), 91
John the Baptist, Saint, 119
Jordan, 80
journey, devotional, 51, 120–22, 124
journey, imagined, 123–26, 136
Judges (book of the Bible), 110
judgment, 94, 98, 107, 110
Julio-Claudian dynasty, 84

K

Kempe, Johanna Wallis, 70
Kerkopes, 107–8, 110–11
kiln, 105
Kröller-Müller, Helene, 38
Kröller-Müller Museum (Otterlo, Netherlands), 38

L

La Daurade, monastery, Toulouse, 125
Landscape, or The Three Graces with the Temple of Venus (Gauguin), 43, *44*
Langlois Bridge, *7*, 8, map 2
Languedoc-Roussillon, 59
Latin, 55, 104, 109–10, 122–23
Lazarus, poor man of parable, 98
Lazarus of Bethany, 73–74
leaf-falls. *See Falling Leaves*
Lens. *See* Bois des Lens
Léon, 132, map 2
Leonard, Saint, 117–18
Le Puy, 117
Le Secq, Henri, 29
letters, 2–8, *7*, 9–11, 17, 20, 22–23, 25–28, 31, 33–37, 42–43, 45, 49–50, 55, 75, 77–78, 135, 137–38, 140; database of, 33, 139
Liber Sancti Jacobi, 121, 127, 132, 141
Limbourg brothers (Herman, Paul, Jean), 15
lime, extraction of, 105–6
limestone, 26, 55, 105–6, 128
lion(s), 28, 108, 110–11
literacy, 123–24
literary influences on Vincent, 4–5, 23, 25–26, 31, 33–35, 77–78, 134–35, 140
local institutions, 93–95, 100–102
London, 12, 27, 29
Louis XIV, 82
Luke (book of the Bible), 98
LUMA Arles, 48–49
LUMA Arles Tower (Gehry), 40–43, *41*, map 1
Lust for Life (Stone), 38
Lyon, 2, 60, map 2

M

Magdeburg, Germany, 16
magi, 95–96, *97*, 100, 102, 104–5
Majeed, Risham, 139
mandarin(e), 34
marble, 26, 53–55, 57, 65, 67–68, 80–82, 91, 103–5, 109, 117, 127–28, 130
Marseille, 6, 52, 61, 76, map 2
Martin (bishop of Tours), 119
Marvels of Rome, The, 84–85
Mary Cleophas (Mary Jacobe), Saint, 141–42
Mary Magdalene, Saint, 74, 99, 117, 141
Mary Salome, Saint, 141–42
Marys (three), 99, 141
Massalia, 52. *See also* Marseille
Matthew (book of the Bible), 95–96, 99, 119
Maupassant, Guy de, 23, 35, 135, 138; *Bel-Ami*, 23, 135, 138; *Pierre et Jean*, 35, 135
Mediterranean, 51, 59, 63, 66, 74, 80, 93
Melencolia (Dürer), 31
mementos, 19–20
memorialization, 126
memory/memories, 130–32, 136–37
Mercure de France, Le, 37–38
Mérimée, Prosper, 47–48, 63, 73, 79, 82, 134; *Carmen*, 134
Méryon, Charles, 29–31, *30*
Met Cloisters museum (New York City), 116

Micah (book of the Bible), 96
Michelet, Jules, 25
Middle Ages, 28, 67, 95, 98, 106, 115, 133
Midi-Pyrénées, 59
military orders, 101–2. *See also* Hospitallers; Templars
mint, 66
Mireille (Gounod), 77
Mirèio (Mistral), 77
mirrors, 20, 22
missionaries, 66
mistral (wind), 38, 49–50
Mistral, Frédéric, 76–78; *Mirèio*, 77; statue of, 76–77, *77*, map 1
Modestus, Saint, 116
Montmartre, 4, 34
Montpellier, 116
monuments, 13, 17, 63, 65, 68, 88, 106, 132, 134, 140
Mountains at Saint-Rémy (van Gogh), 41–42, *42*
Moronobu, Hishikawa, 34
mortar, 105–6
mulberry tree, 19, 57, 140
Mulberry Tree, The (van Gogh), 19, plate 3
museum of antiquities. *See* Musée de l'Arles
Musée de l'Arles et de la Provence antique, 55, 65, 72, 84, 104–5, map 2
Museon Arlaten, 78, map 1
Museum of Modern Art (New York City), 38–39

INDEX

Muslim, 20, 109, 116, 118
Mystère d'Adam, Le, 87

N

Narbo Martius (Narbonne), 59, 60–61, 66, 68, 116–17
narration / narrative frame, 118–20, 129
naval battle, 52–53
Navarrese, 132
necropolis. *See* Alyscamps
Nègre, Charles, 29
Nemean lion, 109
Nero, 28, 73, 84, 134
"Nero the Roman," 26, 73
Netherlands, 7, 13
New York Armory Show (winter 1913), 38
New York Times, 40
nightmare(s), 26, 31, 33, 36, 38
Nîmes, 60, 62, 106, map 2
North Africa, 66
Notre-Dame Cathedral (Paris), 28–29
Notre-Dame-de-la-Mer, church, 141–43; ex voto in, 141–43, *143*. *See also* Saintes-Maries-de-la-Mer
Notre-Dame de Paris (Hugo), 28–29

O

Obert, Claude, 141–43
Occitanie, 59
Octavian. *See* Augustus
Odyssey (Homer), 51

Old Testament, 118
Orange, 80, 116
Otia imperialia (Gervase of Tilbury), 58
Otto IV (emperor), 58

P

Paestum, Hera's temple, 107
pagan/Christian associations, 86–87, 106
Panofsky, Erwin, 134
Parc des Ateliers, 40, map 1
parchment, 121–23
Paris, 2, 4–5, 17, 22, 28–29, 31, 34, 38, 82
Parisian, 5, 12, 23
Park and Pond in Front of the Yellow House, The (van Gogh), 7, *9, 9*
patrimony, 63, 65
Paul (apostle), 92–93
Paulus, 66, 116–17
paving stones, 17–18, 60–61
Pelayo (monk), 104
pentimenti, 138
Père Goriot, Le (Balzac), 34
performance, 126
performers, 109. *See also* troubadours
Persia, 119
Peter, Saint, 74, 91, 125
Petrarch, 5, 9–10
Peytret, Jacques, 69; *Arles Amphitheater as It Is, at Present*, 69
Philip (apostle), 93–94

philologist(s), 76, 124
Philistines, 110
Pierre et Jean (Maupassant), 35, 135
Piles of French Novels and Roses in a Glass (van Gogh), 5
pilgrimage roads, 114–20, 122, 124–26
pilgrims, xi, 1–2, 18–20, *21*, 22, 35, 46, 51, 57, 95–96, 98, 101–3, 111, 113, 127–30, 132, 136, 138, 140–41, 143
Pilgrim's Guide, 18, 51, 57, 85, 98, 100, 104–5, 109, 111, 113–24, 126–33, 135–36, 139
Pisa, 103
Place du Forum, *24*, 63, *64*, 75–76, *77*, map 1. *See also* Café du Forum
Place Lamartine, 5, 9, *9*, map 1
Poe, Edgar Allan, 29, 31; *The Raven*, 29
Poet's Garden, The (van Gogh), 9–11, 37, 140–41, plate 2
Poitiers, 119
Pompey, 52, 55, 84
Pont Flavien (Saint-Chamas), 61, 62
poplar trees, 43, 45, 48
Porcelet family, 95
"porcupine," 17
portal/entry of Saint-Trophime, 25–36, *27*, *28*, 72–73, 78–80, 85–88, plate 5; columns of, 79–80, 85–88; sculptures of, 72–113, *90–92*, *97*, *100–101*, 133–35, 143; Vincent's description of, 26–36
Porte d'Auguste (Nîmes), 62
Porter, Arthur Kingsley, 124–25, 135
Porter, Lucy, 125
portico. *See* forum
prefecture, 66–67, 73
processions, 57–58, 96–98
prostitution, 35, 43, 111–12
Provençal, 2, 18, 77, 99, 111, 118, 123
Provence, 2–3, 58–59, 74, 77–78, 114, 141; counts of, 66
Provincia (Gallia Narbonensis), 58–59, 66
public garden, 5, 9, map 1
Puerta de las Platerías, 128–31, *128*, *131*. *See also* "adulteress"
purgatory, 96–99
Pyrenees, 18, 58, 109, 114, 120, 122

Q

quarries, 80, 106

R

railroad, 2, *3*, 5, 9, 40, 43, 45–49, maps 1 and 2
Railway Storage Yard (van Gogh), 49
Raimond de Montredon (archbishop), 94
Rappard, Anthon van, 33

INDEX {155}

Rastignac, *34*
Raven, The (Poe), 29
Redon, Odilon, 31–33; *Guardian Spirit of the Waters, 32*
reliquary, 115, 128–29, 132
religious primacy, 67
Rembrandt, 25, 39
restoration, 28, 134
Revelation (book of the Bible), 127–28
rhetoric, 36, 121, 126, 129, 131, 136
Rhône River, 2, 46, 52–53, 55–59, 65, 95, 100, 106, 120, 126
Rivière, Théodore Louis Auguste, 77
Road to Tarascon, The (van Gogh), 16–17, *19*, 41–42
Roland (soldier), 18, 109, 118, 120
Roland (bishop), 65
Roman Cemetery (Alyscamps Necropolis and Church of Saint-Honorat, Arles) (Baldus), 46, *47*
Roman roads, 59–62, 68, 116
Roman sites, map 2
Romanesque art/style, 25–26, 79, 124, 133
Rome, 52, 58, 60, 85
Romani, 141
Roncesvalles, 18
Roosevelt, Eleanor, 39
Rouquette, Jean-Maurice, 139; *Arles: Historie, territoires et cultures*, 139
Rousseau, Jean-Jacques, 34
Russell, John Peter, 10

S

Saint-Chamas, 61, *62*, map 2
Saint-Denis, columns for, 85
Saint-Fronto, Périgueux, 118
Saint-Gilles-du-Gard, 99, 106, 114–15; shrine of, 114–15, 128–30, 132, map 2
Saint-Guilhem-le-Désert, 115–16
Saint-Honorat, 43, 46, *47*, map 1
Saint-Jean-d'Angély, 119
Saint-Léonard-de-Noblat, 117–18
Saint-Rémy, 3, 10, 19, 37, 39, map 2
Saint-Romain (Blaye), 109
Saint-Sernin (Toulouse), 105, 117
Saint-Thibéry, 116
Saint-Thierry, 36
Saint-Thomas, 101
Saint-Trophime, 1, 36, 47, 72–74, 85–86, 88, map 1; tower of, 35, 37. *See also* portal/entry of Saint-Trophime
Sainte-Anne, church, later museum, 47, 73, 82–83, 84, map 1
Sainte-Foy (Conques), 117
Saintes, 119
Saintes-Maries-de-la-Mer, 141–43
Saintes-Maries-de-la-Mer, Les (van Gogh), 141, *142*
Saint Peter's Needle (Rome), 84–85
Salon of Independent Artists, 4–5, 40
Salvation, 96–98
Samson, 110
Santiago de Compostela, 74, 103–5, 111, 114, 117–22, 124–26,

INDEX

Santiago de Compostela (*cont.*) 127–32, 135–36, 138, 141, map 2
Santo Domingo de Silos, cloister of, 19–20, *21*, 126
Sarah, Saint, 141
sarcophagi, 43, 46–47, 50, 57–58, 68, 84–85, 98–99, 103–6, 119–20, 123–24
Sarto, Andrea del, 25
Saturninus, in Toulouse, 66, 117
saved, 98–99
scale, 107, 109–10
Scheffer, Ary, 25
Schapiro, Meyer, 133
secular shrines, xv–xvi
self-copying, 6–7, 10–11, 37
Self-Portrait Dedicated to Paul Gauguin (van Gogh), plate 4
self-portraits, 20, 22
Selinunte (Selinus), 107
Seurat, Georges, 33, 40
Shakespeare, 225
sheep, 94–96
sheep and goats, parable of, 96, 99
shrines, 119
Sicily, 107
Signac, Paul, 33, 40
signature, 4
Silos, Santo Domingo de, 126
Sixth Legion (Roman), 52–53
Song of Roland, The, 109, 118
Sotheby's, 39
Spain, 18, 57–60, 80, 85, 95

stade (unit), 113
Starry Night over the Rhône (van Gogh), 37, 40, 55, plate 6
starry sky, 74–75. See also *Terrace of a Café at Night (Place du Forum)*
Stedelijk Museum (Amsterdam), 38
Stephen, Saint, first patron of cathedral, 18, 89, 92–93, 110–11
still lifes, 5, 23, 39
Still Life with Plaster Statuette (van Gogh), 23
Stone, Irving: *Lust for Life*, 38
Strabo: *Geographika*, 55–56
strigil, 105
Styx (river), 58
Suetonius: *De vita Caesarum*, 54
Sugar (abbot), 85
sunflowers, 5, 40

T

Tarascon, 16–17, *19*, 41, map 2
Tartarin de Tarascon (Daudet), 140
Templars, 100–102
Terrace of a Café at Night (Place du Forum) (van Gogh), 23, 74–76, 137–38, plate 8
theater, 63, 65, 67–69, *70*, 72, 80–88, *81*, 106, 112, map 1; columns of, 81–82, 85–86, 104; sculptures from, 82–84, 106; stage, 80–81
Theo, brother of Vincent, 2–5,

10–11, 17, 20, 22–23, 25, 31, 33–35, 37, 40, 43, 50, 75, 78, 135
theological training, 55
theologians, 86, 96
Three Beauties of the Present Day (Utamaro), 13
three Marys, 141
Tiberius, Saint, 84, 116
Tolosa, 59. *See also* Toulouse
tombs, 1, 45–48, 61, 68, 104, 116, 119–121, 127
Touloubre River, 61
Tours, 119
Toulouse, 59, 66, 68, 105, 109, 117, 125; counts of, 59, 116, 123, 133; house of, 115
travel destination, 40, 122
treachery, 110–11
Très Riches Heures du Duc de Berry (Limbourg brothers), *15*
trickster, 107, 110
Trier, 66–67
Trinquetaille, 57, 100–101, map 2
Trophimus, Saint, 2, 66, 73–74, 89–91, 95, 110, 116–17, 124
troubadours, 116, 124
Turkey, 80
Turpin (archbishop), 109

U

"Unibos" (fable), 109–10
Utamaro, Kitagawa: *Three Beauties of the Present Day*, 13

V

Valentinian (emperor), 57
Vampire, The (Méryon), 29, *30*
van Gogh, Vincent, works of:
 The Alyscamps, 1, 45–46, 48, plate 1; *Arena at Arles*, 13, *16*; *L'Arlésienne*, 22; *Arles: View from the Wheatfields*, 12–13, *14*; *Falling Leaves (Les Alyscamps)*, 43, 45, *45*; *Irises*, 39–40, plate 7; *Mountains at Saint-Rémy*, 41–42, *42*; *The Mulberry Tree*, 19, plate 3; *The Park and Pond in Front of the Yellow House*, 7, 9, *9*; *Piles of French Novels and Roses in a Glass*, 5; *The Poet's Garden*, 9–11, 37, 140–41, plate 2; *Railway Storage Yard*, *49*; *The Road to Tarascon*, 16–17, *19*, 41–42; *Les Saintes-Maries-de-la-Mer*, 141, *142*; *Self-Portrait Dedicated to Paul Gauguin*, plate 4; *Starry Night over the Rhône*, 37, 40, 55, plate 6; *Still Life with Plaster Statuette*, 23; *View of Arles*, frontispiece; *View of Arles on the River Rhône*, 55, *56*
Van Gogh: A Power Seething (Bell), 139–40
Van Gogh Bridge, 7, map 2
Van Gogh Museum (Amsterdam), 23
van Rappard, Anthon, 33

Venus of Arles, sculpture, 82–84, *83*
vernacular, 123
Vézelay, 74, 117, 133, 141
Via Agrippa, 60
Via Aquitania, 59, 116
Via Aurelia, 60–62, 68, map 2
Via Domitia, 59–61, 116
Via Julia Augusta, 60
Vichy, 76
Vienne, 2, 60, 66–67
View of Arles (van Gogh), frontispiece
View of Arles on the River Rhône (van Gogh), 55, *56*
Vincent's Books (Guzzoni), 140
Viollet-le-Duc, Eugène-Emmanuel, 28, 31
Virgin Mary, 128–29
Visigothic, 104
vision, theories of, 20, 22
Vitruvius: *De architectura*, 80
Vollard, Ambroise, 38

W

walls, 40, 62–63, 65, 86, 98, 112, map 1
weather, 28, 36, 49–50, 112
weighing of souls, 107, 110
weights, 94
Wharton, Edith, 26
Willemien, Vincent's sister, 2, 17, 23, 25, 31, 33, 75, 135
William (abbot), 35–36
William of Gellone, Saint, 115–16, 118
woodcuts. *See* Japanese prints
World War I, 48, 125
World War II, destruction caused by, 8–9, 16–17, 52, 61, 76–78, 122; writing, 25–27, 31, 33–36, 123–24

Y

yellow house, Vincent's in Arles: 1, 6, 8–10, *9*; painting of, 8–9; painting of bedroom in, 10–11, 37, 137, map 1

Z

Zosimus (pope), 67
Zouaves, 35